Reflections on the
Imitation of Greek Works

Reflections on the Imitation of Greek Works in Painting and Sculpture

Johann Joachim Winckelmann

Complete German text,
with a new English translation
by Elfriede Heyer and Roger C. Norton,
State University of New York
at Binghamton

Open ✳ Court
La Salle, Illinois

OPEN COURT and the above logo are registered in the U.S. Patent and Trademark Office.

Translated from the original German essay *Gedanken ueber die Nachahmung der griechischen Werke in der Malerei und Bildhauerkunst* (1755).

Printed and bound in the United States of America.

Library of Congress Cataloging-in-Publication Data

Winckelmann, Johann Joachim, 1717-1768.
 Reflections on the imitation of Greek works in painting and sculpture.

 Bibliography: p.
 1. Imitation (in art) 2. Art, Greek — Influence
I. Title.
N7428.W513 1986 709'.03'3 85-28901
ISBN 0-8126-9018-4
ISBN 0-8126-9056-7 (cloth)

Table of Contents

Preface

Johann Joachim Winckelmann's first publication, the pamphlet *Reflections on the Imitation of Greek Works in Painting and Sculpture* (1755), became the cornerstone of his aesthetic theory and met with instant success even though the initial edition consisted of only fifty copies. So strong was the appeal of this essay to a European audience enlightened by philosophers from Shaftesbury to Hume and from Montaigne to Voltaire, that it was quickly translated into several languages and became a topic of discussion in the salons of Paris as well as the coffeehouses of London. A translation into English appeared in 1765, only ten years after its German publication: Henry Fusseli, *Reflections on the Painting and Sculpture of the Greeks with Instructions for the Connoisseur, and an Essay on Grace in Works of Art* (London 1765, reprinted in 1767). Another English translation by an anonymous source was printed during the same decade: *Reflections concerning the Imitation of the Grecian Artists in Painting and Sculpture. In a Series of Letters* (Glasgow 1766). With the appearance of Gotthold Ephraim Lessing's *Laocoon* in 1766 as a direct response to Winckelmann's aesthetic theory of Greek classicism, the *Reflections* once again became an object of discussion, given impetus by the fact that Winckelmann had recently published his *History of Ancient Art* (1764), a work that established his fame among the pioneers of archeology and art history.

No additional translation of the *Reflections* into English has appeared in the more than two hundred years since. Art historians and aestheticians studying Winckelmann but not familiar with the 18th century German idiom have had to rely on outdated translations when available at all — mostly the Fusseli edition — or else present their own rendition of what they felt the original text was trying to say. In either case, injustice has been done not only to the English reader, who often had to accept questionable interpretations, but also to Winckelmann, whose style, especially in translation, has suffered much censure of its supposedly archaic or whimsical character. Moreover, references to Winckelmann in English criticism

are often based on limited selections from the *Reflections* as quoted in Lessing's *Laocoon*, since modern translations of Lessing's work into English made those particular passages more accessible. The pitfall of this method is the fact that it encourages quoting out of context and thus may contribute to a misconception of Winckelmann's aesthetics.

The source of our translation of the *Reflections* is the second, enlarged edition and is entitled as follows: Johann Joachim Winckelmann, *Gedanken ueber die Nachahmung der griechischen Werke in der Malerey und Bildhauerkunst*, Zweyte vermehrte Auflage (Dresden und Leipzig: Im Verlag der Waltherischen Handlung, 1756). The text has been translated in its entirety. The German text included with our translation is that of the Reclam edition of 1969; it is identical with the second, enlarged edition mentioned above except that the orthography has been modernized to some degree. Apart from modernization of spelling and our insertion of sub-headings (following Fusseli's example) the German is thus identical with Winckelmann's.

We are very grateful to the following individuals for their reading of the manuscript and for their helpful comments and corrections: Kenneth C. Lindsay, Professor of Art History; Penelope C. Mayo, Assistant Professor of Art History; and Stephen D. Ross, Professor of Philosophy.

Introduction

Johann Joachim Winckelmann's pioneering works have made a decisive mark on German intellectual life and on the development of aesthetics and art history in general from the 18th century to our present time. His personal discovery and exploration of ancient Greek art ignited the enthusiasm of contemporary European artists and stimulated a great outpouring of literary writings, criticism, translations from the Greek, as well as theoretical and philosophical reflections. Since Winckelmann lived at the beginning of a new era, he was probably not aware of the definite direction in which he was guiding his generation. But there was no doubt in the minds of his eighteenth century followers that the Enlightenment would have taken a different course without him. He was acknowledged to be the founding father of German Classicism. Herder and Goethe wrote laudatory essays about him, and Goethe is known to have taken his Italian journey with Winckelmann's *History of Ancient Art* as a constant companion. Winckelmann's influence did not diminish with the passing of time; during the nineteenth century, the renowned scholar Carl Justi produced, with the methodological exactitude peculiar to positivistic scholarship, a three-volume monograph, *Winckelmann und seine Zeitgenossen* (Winckelmann and his Contemporaries), the title and length of which suggest the continued high esteem accorded Winckelmann's accomplishments.[1] At the beginning of the present century and to some extent through the period of the Third Reich, German Classicism would have seemed incomplete without the idealized and by then highly stylized concept of Winckelmann as its initiator and source of genius.

The general rejection of an idolized past in Germany after World War II included the shattering of many myths and legends that had been built up around Winckelmann and German Classicism, but, unfortunately, Winckelmann's authentic picture suffered much distortion in the process. Notwithstanding continued respect for his achievements, especially in archeology and art history, and his influence on 18th century cultural development, there

was a lack of comprehensive and constructive Winck-
elmann scholarship for the first few decades following
World War II. It appeared as if certain inconsistencies and
contradictions in some of his basic concepts had penetrated
the criticism itself, producing much fruitless argumenta-
tion and dividing his critics into seemingly irreconcilable
opposing camps.[2] Only recently has there been a refocuss-
ing of research on his positive contributions to aesthetics
and cultural history that promises to provide a new basis
for meaningful discussion and discovery. An important
reason for scholarly puzzlement had been his proclamation
in the *Reflections* that the only way for young German art-
ists and writers to become great, even "inimitable", was
by imitating the Greeks. Among some modern critics, it
also became customary to consider it a shortcoming of
Winckelmann that he lacked understanding of the art of
his time and its implicit trends, that he was blind to a new
literature just budding in Germany, and that he would
rather cast his eyes exclusively on the glories of a distant
past. But if we consider the many changes in world outlook
that were taking place during the early Enlightenment
period in Germany, we must ignore 20th century hindsight
and look at things from the perspective of the 18th cen-
tury. In so doing, we note how the idea of progress and
cultural development was constantly being challenged by
certain human needs for norm and structure, at a time
when a very old system of rules and values had come out of
joint without having been replaced by a new and better
one. This ideological vacuum was intensified by the par-
ticular political and intellectual climate existing in Ger-
many during Winckelmann's youth. Since there was little
at home with which he could identify, Winckelmann
yearned toward a past age when political, geographical
and artistic conditions enjoyed, as he believed, such
reciprocal relationships and harmony as were necessary for
the creation of the highest beauty. Herder would later say
that in his soul Winckelmann had really become a Greek.[3]
Intellectually however, he was very much a product of
modern Rationalism, a self-made man of the Enlighten-
ment in the truest sense of the word. With the recognition
that inconsistencies in Winckelmann's writings are time-
related and inherent in the structure of his age, we can turn

our focus, as it were, upon the early Enlightenment in Germany and once more, like Winckelmann's contemporaries and immediate successors, examine his actual accomplishments.

Winckelmann was born in 1717 in Stendal, a small provincial town located about 50 miles west of Berlin in today's East Germany, a place that — as Wolfgang Leppmann says in his *Winckelmann* biography — had never quite recovered from the devastation suffered during the Thirty Years' War a century before. As the child of a cobbler, he had to confront all the obstacles in the educational pathway of a poor man's gifted son. He began his ascent by reading for a blind school principal in exchange for free board and room, and by singing in Latin for pocket money as a member of an itinerant boys' choir. The subjects generally taught in the basic school (*Lateinschule*), were religion, history, Latin rhetoric, and some Greek; the German language was not yet included as a discipline, and German literature consequently remained for many years a subject to be discussed only in certain intellectual circles. We must remember that Christian Wolff caused considerable furor at the University of Halle during these years when he challenged the tradition of Latin language dominance by delivering some philosophy lectures in German, as had Christian Thomasius before him. Interestingly enough, however, it was not so much Latin that aroused Winckelmann's interest in classical languages but the much less popular Greek. And it was in order to better pursue his Greek studies at the Gymnasium that he went to Berlin in 1735 at the age of eighteen. To earn a livelihood he became a private tutor, the lowly and sole available occupation of many a destitute scholar or artist of the time.

When he went to Halle in 1738 to begin his university education, he began the study of theology primarily because his parents and teachers expected him to do so; it was the most likely discipline for a man of Winckelmann's background and means since it was subsidized by the church and state. Furthermore, it was perhaps the only subject that promised a secure and respected lifetime position for the bourgeois scholar. But instead of faithfully attending theology lectures, Winckelmann acquired in Halle a general knowledge of philosophy, history, and literature,

and having been all of his life an ardent reader who would not mind walking many miles for a book at a distant library, he directed the course of his studies very much on his own. With a document of sorts that certified his matriculation in theology, Winckelmann left Halle after two years and returned to the position of private tutor in order to replenish his funds. A year later he enrolled at the University of Jena as a student of medicine, an undertaking he terminated even sooner than his work in theology.

Unwilling to enter the ministry and disillusioned by scientific studies, Winckelmann once more became a tutor until, in 1743, through the help of friends he was offered the low-paying position of *Konrektor* at the *Lateinschule* in Seehausen, a medieval country town in the Altmarck, not far from his native Stendal. Educated far beyond this calling, confronted by a body of students uninterested in academic endeavors, and, finally, exposed to the chicaneries of church and city officials, Winckelmann found solace in books from which he made many excerpts in his careful handwriting. He had taught himself to read English, French, and Italian, but he spent most free hours reading the classical Greeks in the original. The last German edition of Plato dated from 1602, before the Thirty Years' War, and Homer had been published only once in almost a hundred and fifty years. Consequently, these texts not only were rare but beyond Winckelmann's means, and he thus spent countless hours copying from borrowed books. For nights on end, Winckelmann would never leave his armchair for fear he might waste too much time sleeping, and he claimed in a letter to a friend "that he had so toughened his spare and rather tall frame that he could get along on no more than two or three hours' sleep."[4] Later, he would refer to these five Seehausen years as his "time of slavery", a period in which he nonetheless laid the groundwork for his prodigious knowledge. By sheer coincidence Winckelmann heard of an open position, for which he immediately applied, as librarian and secretary to a former Saxon diplomat, Count Heinrich von Bünau, in Nöthnitz near Dresden. When his application was accepted and Winckelmann left Prussia for Saxony in the year 1748, he had arrived at the turning point of his life.

To maintain historical perspective it should be men-

tioned that we are speaking of a time when North America was still a group of colonies, when Frederick the Great had been King of Prussia for several years, had just built Sanssouci Palace in Potsdam, and had yet to fight the Seven Years' War. When Winckelmann left Prussia in 1748, Kant was just twenty-four years old and still unknown; Bach and Handel were still alive, and baroque music was reaching its zenith, while the world had still to wait eight years for the birth of Mozart; it was one year before Goethe's birth; Klopstock was writing the *Messias*, and Lessing's first comedy, *The Young Scholar*, had just been published. In 1748 David Hume's *Treatise of Human Nature* was making its impact on the development of the German Enlightenment, and Montesquieu's *L'Esprit des lois*, was published. The influence of both Montesquieu and Hume on Winckelmann's aesthetics is easily noticeable. The first excavations in Pompeii had come to light, and helped to provide inspiration for the archaeological and historical studies that would contribute to Winckelmann's fame. Winckelmann was a contemporary of Voltaire, who is said to have been the first to use the term 'Philosophy of History'. Voltaire radically altered the writing of history by treating the total cultural condition of a nation rather than merely writing the history of kings, their wars and victories. But while Voltaire was the first historian to penetrate the entire spirit of an age, to touch upon its political, economic, and religious conditions, it was Winckelmann who would write the first 'scientific' history of art. This novel undertaking was to become vital to the development of aesthetics, since it helped shift taste and beauty to a time-related historical perspective. In the fields of literature and art, this was to be a final breakthrough from a closed cyclical world view that had still dominated much of seventeenth century thought, to the realization of history unfolding as an open-ended process. While the cyclical world concept presupposed repetition of historical occurrence and thus served as a philosophical basis for maintaining unchanging universal aesthetic norms, the idea of history progressing in a linear fashion involved acceptance of change and development.

As we mentally reconstruct some particular historical circumstances in the earlier part of the eighteenth century,

specifically in Germany, we must call to mind that prior to Winckelmann's time, art history consisted primarily of cataloguing, numbering, and quite superficially describing works of art, which, for the most part, decorated the halls and private chambers of princes, or court libraries, and state treasuries. One such outstanding private art collection existed in Dresden, capital of the little duchy of Saxony, which by the middle of the eighteenth century had developed into a cultural center adorned with magnificent works of art and architecture. Thus, when Winckelmann began his duties as secretary in Nöthnitz, the proximity of Dresden was a decisive factor in his future development. Furthermore, Count Bünau owned—in Winckelmann's own words—not only the largest private library in Germany, but one of the best private libraries in all of Europe. Winckelmann's assignment was to catalogue these holdings and make occasional excerpts from historical sources which Bünau needed for his extensive research and work on a 'History of the German Empire', or *Kayser- und Reichshistorie*. The easy access to books here satisfied Winckelmann's desire for general knowledge while his study of the considerable collection of Italian and Dutch paintings of the 16th and 17th centuries in the art gallery of Duke Augustus the Strong and the antique statues in the royal *Antikensaal* initiated him into aesthetics and art. In addition, he met some influential people connected with the court of Dresden who inspired and supported him. They recognized his outstanding talents and offered him a journey to Rome and a possible position there. A considerable obstacle to all of these tempting prospects was Winckelmann's Lutheran background in a thoroughly Catholic environment; the Electorate of Saxony had changed its official religion when Frederick Augustus I became Roman Catholic in order to add the coveted title and accompanying prestige as King of Poland to his name. Since the kingship of Poland was passed on to the Elector's successors, many visitors to the Dresden court, as well as Winckelmann's future patrons, had close relations with the Vatican. The inevitable and unalterable condition attached to such patronage was Winckelmann's conversion to Roman Catholicism.

Winckelmann was not a strong believer; his interests

were certainly not rooted in the realm of dogmatic theology. Nevertheless, for several years he resisted the cultural attractions and promises of Rome which must have seemed a Mecca to a man yearning for art treasures of the past. After much soul-searching and hesitation, he finally yielded to the persuasion of Count Alberigo Archinto, Papal Nuncio to the Court of Saxony, and in 1754, six years after arriving in Nöthnitz, converted to the Roman Church. His parents, who by now were both deceased, would have been hurt most by this decision. In any case, Winckelmann's move was received with shock and great indignation by many of his friends and acquaintances. The misunderstandings and remonstrations following Winckelmann's conversion might have contributed to the fact that he never returned to Germany after leaving for Rome. Before his departure, however, he lived for a year in Dresden, where he spent much time in the company of the renowned painter Adam Friedrich Oeser, who instructed him in drawing and under whose guidance Winckelmann ventured into the creative realms of art.

Inspired by his frequent visits in Oeser's house and the royal *Antikensaal*, which housed a collection of antique sculptures, Winckelmann wrote the *Reflections on the Imitation of Greek Works in Painting and Sculpture* (1755). The carefully executed publication contained an elaborate dedication to the king and three engravings done by Oeser. Only fifty copies were printed initially, but this small work aroused so much interest and response that it was soon translated into the leading European languages. Encouraged by this sudden recognition, and before departing for Rome, Winckelmann wrote anonymously a follow-up essay entitled *Open Letter on the Reflections* (*Sendschreiben*), in which he ridiculed his own work and thus, with tongue in cheek, demonstrated his anticipation of public criticism. It is also quite possible that Winckelmann's first taste of publicity had whetted his appetite and that he cleverly used the *Open Letter* as a pretext for elaborating in more detail the philosophical theories presented in the *Reflections*. Because, only a short while later, there followed a sequel called *Commentary to the 'Reflections' . . . and Reply to the 'Open Letter' on these 'Reflections'* (*Erläuterung der Gedanken . . . und Beantwortung des Sendschrei-*

bens über diese Gedanken) in which Winckelmann
deliberates on the theses brought forth in the first publica-
tion. Neither of the two sequels shows the elegance of style
and logical tightness of the *Reflections* but they effectively
clarify and further develop, with both humor and erudi-
tion, its main ideas.

Although Winckelmann's later writings helped to es-
tablish his fame in art history, the *Reflections* of 1755,
delineating a basic aesthetic tenet, remains his seminal,
decisive work. The general principles laid down in this ear-
ly essay were crucial for all his subsequent thinking. The
work starts *in medias res*, as it were, with the thoughts
closest to his heart, as the first paragraphs state some of
Winckelmann's most decisive categories: the uniqueness of
ancient Greek art as a result of the favorable Greek climate
in combination with destiny and genius, and, very impor-
tantly, good taste, the celebrated *bon goût* of French Neo-
Classicism, which still figured high on Winckelmann's list
as a metaphysical, that is universal and therefore timeless,
a priori category. From Montesquieu he had learned that
the rise and fall of nations result from changes taking place
within a set of more or less constant factors which govern a
particular nation's life, extending from geographical loca-
tion and weather to the amount of political freedom it en-
joys. Indeed, the two factors, climate and politics, became
the axis for Winckelmann's theory concerning the ex-
emplary nature of Greek art. The idea of climate influenc-
ing the health of soul and body, determining manners,
taste, habits—in short, conditioning the total perception of
life—was a new and exciting concept for the eighteenth
century. While Montesquieu was specifically interested in
examining the effect of geography and climate on laws and
legal systems governing men in various countries and ages,
Winckelmann was especially inspired by this new concept
because it offered to him a logical explanation for the out-
standing physical beauty and grace he found depicted in all
forms of Greek art. He argued that a milder climate must
have caused early physical and mental maturity among
Greek youths, and that intense gymnastic exercise probab-
ly kept their blood in moderately rapid circulation and
perfected their bodily form. When one added to this the
deep blue sky of the south, the warm sun and brightness of

color, the artist would, in Winckelmann's view, simply need to open his eyes to find his ideal in the natural and social environment surrounding him.

Small wonder that eighteenth century literature and poetry should be replete with expressions of yearning for such an earthly paradise; many people were drawn to Italy, which spiritually and physically seemed the closest approximation to distant Greece. For Goethe, the Italian journey was a high point in his life, symbolically captured in that famous first line of his Journal: "Auch ich in Arkadien!" ("I, too, am in Arcadia!"). Goethe's eagerness to journey to Italy in the late 1780s might have been stimulated by Winckelmann's enthusiasm for antiquity, but there is also enough evidence that there was an increased interest in the habits and customs of other cultures in general at that time. While Winckelmann was pursuing his new-found connection between art and its physical surroundings, the young Herder was attentively listening to Kant's lectures in Königsberg on physical geography. This was during Kant's pre-critical period, when he collected and analyzed reports from Protestant and Jesuit missionairies in distant continents to gather insights into the religious and cultural habits of Africa, the Orient, and North and South America. All of these factors contributed to a slowly changing picture of the world in the eighteenth century and to a basic revision of traditional norms hitherto considered universal and therefore immutable. The realization that taste was indigenous to each culture, with its particular customs, religion, and traditions, and not universally identical, came only as a result of this new historical understanding.

As for Germany itself, one must keep in mind that intellectual and literary development there had been slow in comparison with that of its European neighbors, and that Winckelmann stood only on the threshold of a collective surge of intellectual and artistic creativity that began in the early 1760s with Lessing, Wieland, and Kant, and continued almost without interruption into the early nineteenth century. Historically and ideologically he did not identify with the new epoch just evolving in Germany. Although, with his self-taught English, he had read Shaftesbury and Hume and supposedly knew Pope's

"Essay on Man" almost by heart, he took little notice of contemporary literary productions in his native land and language. At a time when Klopstock's celebrated *Messias* and Lessing's early works were the talk of literary circles, Winckelmann's vision was already focussing more and more upon the distant past. Since his own time had little to offer that assured his political and intellectual freedom or that pleased his taste, Greek antiquity became his great and life-long love and he searched for it with all his soul.

In Rome, where he arrived in November 1755 on a travel stipend that was to take him also to Naples, Herculaneum, and Florence, and where he later settled as curator, librarian, and finally as Papal Antiquary and *Scriptor*, Winckelmann discovered to his great surprise that the Romans knew very little about the treasures deposited in their museums and galleries. Convinced that these included some of the finest examples of Greek sculpture, of inestimable value both as records of the past and as models for the future to be followed by every artist, he set about examining them piece by piece, compiling an inventory and laying the groundwork for his *History*. Previously, productions of art had scarcely been discussed in such detailed and erudite manner. A writer of Winckelmann's lucid style was needed to open this rich but undeveloped area. He not only provided access to a long forgotten treasure of the past, but by describing it he painstakingly created, with great knowledge and intuition, a new genre and turned the writing of art history into an art itself.

Winckelmann's *History of Ancient Art*, his *magnum opus* published in 1764 in Rome, contains all the necessary ingredients for demonstrating a linear movement in history. As Winckelmann states in the introduction, the *History* serves to investigate "the origin, growth, change, and decline of classical art together with the styles of various nations, times, and artists." It starts with an analysis of oriental art, then focusses on the Etruscans and moves to its central subject: the different art periods of Greek culture. The Romans are treated peripherally in conclusion. In all stages of his investigation, Winckelmann keeps a watchful eye on historical environments, or "outward conditions" as he calls them, and the way these con-

ditions shaped the art of a certain time. Such a genetic ap-
proach to the development of art seems historically and
methodologically progressive, almost revolutionary for its
time. A closer investigation of content, however, reveals
the overwhelmingly dogmatic character of Winckelmann's
aesthetics, which conflicts with his intuition concerning the
laws governing historical processes. For it is Greek art, and
particularly Hellenic art, that occupies the center of
Winckelmann's work and interest. It constitutes an ab-
solute norm, a model against which everything else is held
and judged. There was indeed a definite movement in the
history of art, but it was geared toward *one* culmination.
In the eyes of Winckelmann, beauty in all its conceivable
constellations reached an insurmountable peak during the
fourth century B.C. and declined steadily thereafter—ex-
cept for a short interval in the Renaissance—and reached
its nadir in the baroque art of the seventeenth and early
eighteenth centuries, a style he thoroughly detested. Aes-
thetically, there was but one way which would lead to the
resurrection of art and beauty: the faithful adherence to
rules and laws established by the ancients and exemplified
in their masterpieces.

The dilemma of Winckelmann's aesthetics was that it
led him to an illogical conclusion. Systematic imitation of
the ancients was historically unfeasible and of little prac-
tical use for the very reason Winckelmann had demon-
strated so brilliantly, namely that the development of
Greek art was determined by its particular environment:
the climatic, social, and political conditions that made it
unique. It is the irony of Winckelmann's genius that his
dual role as modern historian and conservative aesthetician
caught him on a one-way road looking back with nostalgia
while erecting signposts pointing in the opposite direction.
Winckelmann's "Janus"-faced vision did not greatly affect
18th century aesthetics and literature. But with the passing
of time, critics tended to become less tolerant of him, and
while criticizing the inherent paradoxes of Winckelmann's
thought, they often failed to recognize his great strength,
which lay in revealing the subtleties of the differences be-
tween individual cultures and ages. Since Winckelmann
viewed such differences as products of climate, race, time,
and geographical location, he consequently perceived the

artistic outcome as conditioned by the confluence of political structures as well as religious and philosophical trends. This certainly was an entirely new approach to cultural investigation and a revolutionary concept of history.

Herder freely admitted later that Winckelmann's pioneering work had prepared the way for his own organic view of history. He soon detected the shortcomings of Winckelmann's preferential treatment of the Greeks and his emphasis on their role in history, but this very treatment also helped to free Herder all the sooner from his own exaggerated veneration of the Greeks and to let him see their culture as an integral part of the evolutionary process in history. Rather than criticizing Winckelmann's inconsistencies, Herder recognized him as a genius in his own right. Winckelmann's extraordinary ability to enter into the spirit of an age long past, to understand and analyze its art works by sheer power of intuition, Herder considered unique. Hence, in his eyes Winckelmann was an *Originalgenie* and as inimitable as the Greek masters themselves. What Herder may have had in mind in praising his genius can perhaps best be demonstrated by lines from the description of the *Torso Belvedere* in Rome, where Winckelmann reflects on this mutilated statue which he supposed to be that of Hercules: "At first glance you may detect nothing more than a disfigured rock; but if you have the power of penetrating the secrets of art you shall behold one of its wonders . . . Hercules will soon appear before you amidst all his ventures, and this piece of stone will reveal to you the Hero and the God at the same time."[5] It was this power of intuition and contemplation in the approach to art that inspired Herder and made him speculate upon its possible similarity with perceptions of language and poetry. To him, Winckelmann's single-minded preoccupation with Greek art and his admonition to imitate it had nothing in common with the *imitatio* concept of French Classicism, which for Herder was nothing but a meaningless mask. Even French writers and artists of the eighteenth century who regarded themselves as heirs to the ancient tradition praised Winckelmann's extraordinary scholarship. A Parisian periodical asked: "Who has better studied the admirable monuments which remain to us,

who is more sensible to their beauties, and who knows how to describe them with more justice, taste and fire?"[6]

Thus Winckelmann's reputation, not only as an archeologist and cultural historian but also as a leading aesthetician, was considerable among his contemporaries and continued to grow in the remainder of the eighteenth century. The discussions inspired by Winckelmann during and after his lifetime prove to us that the realization of the historicity of Greek art by no means lessened its fascination. On the contrary, attention was turned away from questions of norms and directed to those qualities which give particular works of art their undiminished appeal and greatness. In the wake of the *Querelle des ancients et des modernes*, France had, in the early part of the century, already experienced its Homer Renaissance. By being considered now from a historical perspective, the qualities in Homer's works, which had hitherto been criticized as 'archaic' could be appreciated as invaluable manifestations of his time and unique genius. Winckelmann's thoughts and writings on classical Greek art had, so it seems, opened a rich vein. Its effect on Goethe, Schiller, and the entire German classical period and beyond is legend.

When we look in retrospect at Winckelmann's time we can observe the slow development of an entirely new consciousness. The eighteenth century was shedding the mantle of a two thousand year old tradition, questioning established metaphysical systems, and moving hesitantly toward a different notion of time and history. It was a period of beginning *Mündigkeit*, an age when man came slowly to realize it was not some super-historical force or authority but he himself who determined the course of his destiny. Thus, modern man became creative, in other words, *original*, inasmuch as he understood himself to be historical. A concrete rather than abstract historical condition projected a completely new meaning into prevailing ideas and so established different precepts for man's understanding of self in the creative process. A progressive, open-ended concept of history had to place notions of universal standards such as Truth and Beauty into relative perspective, and insofar as the traditional horizon of absolute norms was transcended, normative aesthetics and history had no common measure.

This fundamental change of direction added a larger dimension to the function of taste, subjective choice, and aesthetic freedom, and confronted the era of rationalism with questions of a complexity that defied simple solutions. There was no return to answers secured by tradition, nor were abandoned concepts to be easily replaced by new definitions. The beginnings of modern historical thought imposed demands and standards upon the form of philosophical and theoretical thinking which Winckelmann, as one of its innovators standing at the crossroads, was not yet capable of meeting. He was not consciously aware of a fundamental contradiction in his own theory since he never attempted to consolidate his notions of history and aesthetics. He might have, had he been allowed to live twenty or thirty years longer.

During his last years, which he spent largely in Rome, Winckelmann was held in such high repute that scholars and princes asked for his counsel when they visited the Eternal City. These visitors, in turn, were greatly impressed by his knowledge and personality and they took home with them what they learned from him. Influential people in Germany tried to win him back and arranged for him to be offered a position as director of a library at the Court of Frederick the Great. Even the francophile Frederick admired Winckelmann's achievements and was willing to make an exception by considering a German scholar for the job. When the offer arrived in 1765, Winckelmann at first was inclined to accept and to return in triumph to the place he had left empty-handed seventeen years earlier. He would see old friends again, meet the group of writers gathered around Nicolai in Berlin, and perhaps speak to Lessing who had so eloquently responded to his *Reflections*. But the conditions that Winckelmann attached to his acceptance of the position negated all hopes for its approval by the king. Three years later, against all previous intentions and inclinations, he did start out on a trip to Germany. But as if pursued by his own aesthetic vision that 'good taste' would wane and diminish by degrees if transplanted into northern and colder zones, he was so appalled upon seeing the Alps—not only by the height and precipitous appearance of the mountains but also the "ugliness" of the Alpine houses—that he wanted to return

to Rome immediately. Only with much persuasion could his companion convince him to go as far as Vienna, where he was expected at the Court of Maria Theresa. After having been received there with honors and gifts, he journeyed to Trieste in order to return to Rome by boat. Shortly thereafter in Leipzig, where the young student Goethe, together with Oeser, were awaiting the arrival of the famous man, the shocking news was received that Winckelmann at the age of fifty had been murdered by the hand of an adventurer in his hotel room in Trieste.[7]

Gedancken
über die
Nachahmung der Griechischen
Wercke
in der
Mahlerey und Bildhauer=Kunst.

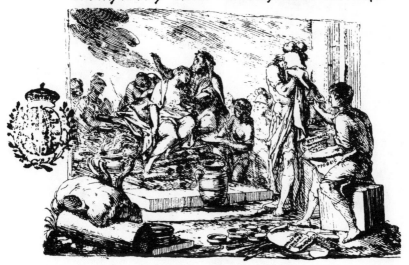

Vos exemplaria Græca
Nocturna versate manu, versate diurna.
HORAT. ART. POET.

1755.

Reflections on the
Imitation of Greek Works
in Painting and Sculpture

I. Die schöne Natur

Der gute Geschmack, welcher sich mehr und mehr durch die Welt ausbreitet, hat sich angefangen zuerst unter dem griechischen Himmel zu bilden. Alle Erfindungen fremder Völker kamen gleichsam nur als der erste Same nach Griechenland, und nahmen eine andere Natur und Gestalt an in dem Lande, welches Minerva, sagt man, vor allen Ländern, wegen der gemäßigten Jahreszeiten, die sie hier angetroffen, den Griechen zur Wohnung angewiesen, als ein Land welches kluge Köpfe hervorbringen würde.

Der Geschmack, den diese Nation ihren Werken gegeben hat, ist ihr eigen geblieben; er hat sich selten weit von Griechenland entfernet, ohne etwas zu verlieren, und unter entlegenen Himmelstrichen ist er spät bekannt geworden. Er war ohne Zweifel ganz und gar fremde unter einem nordischen Himmel, zu der Zeit, da die beiden Künste, deren große Lehrer die Griechen sind, wenig Verehrer fanden; zu der Zeit, da die verehrungswürdigsten Stücke des Correggio im königlichen Stalle zu Stockholm vor die Fenster, zu Bedeckung derselben, gehänget waren.

Und man muß gestehen, daß die Regierung des großen Augusts der eigentliche glückliche Zeitpunkt ist, in welchem die Künste, als eine fremde Kolonie, in Sachsen eingeführet worden. Unter seinem Nachfolger, dem deutschen Titus, sind dieselben diesem Lande eigen worden, und durch sie wird der gute Geschmack allgemein.

Es ist ein ewiges Denkmal der Größe dieses Monarchen, daß zu Bildung des guten Geschmacks die größten Schätze aus Italien, und was sonst Vollkommenes in der Malerei in andern Ländern hervorgebracht worden vor den Augen aller Welt aufgestellet sind. Sein Eifer, die Künste zu verewigen, hat endlich nicht geruhet, bis wahrhafte untrügliche Werke griechischer Meister, und zwar vom ersten Range, den Künstlern zur Nachahmung sind gegeben worden.

Die reinsten Quellen der Kunst sind geöffnet: glücklich ist, wer sie findet und schmecket. Diese Quellen suchen,

I. Natural Beauty

Good taste, which is becoming more prevalent throughout the world, had its origins under the skies of Greece. Every invention of foreign nations which was brought to Greece was, as it were, only a first seed that assumed new form and character here. We are told[1] that Minerva chose this land, with its mild seasons, above all others for the Greeks in the knowledge that it would be productive of genius.

The taste which the Greeks exhibited in their works of art was unique and has seldom been taken far from its source without loss. Under more distant skies it found tardy recognition and without a doubt was completely unknown in the northern zones during a time when painting and sculpture, of which the Greeks are the greatest techers, found few admirers. This was a time when the most valuable works of Correggio were used to cover the windows of the royal stables in Stockholm.[2]

One has to admit that the reign of the great August[3] was the happy period during which the arts were introduced into Saxony as a foreign element. Under his successor, the German Titus, they became firmly established in this country, and with their help good taste is now become common.

An eternal monument to the greatness of this monarch is that he furthered good taste by collecting and publicly displaying the greatest treasures from Italy and the very best paintings that other countries have produced. His eagerness to perpetuate the arts did not diminish until authentic works of Greek masters and indeed those of the highest quality were available for artists to imitate. The purest sources of art have been opened, and fortunate is the person who discovers and partakes of them. This

heißt nach Athen reisen; und Dresden wird nunmehro Athen für Künstler.

Der einzige Weg für uns, groß, ja, wenn es möglich ist, unnachahmlich zu werden, ist die Nachahmung der Alten, und was jemand vom Homer gesagt, daß derjenige ihn bewundern lernet, der ihn wohl verstehen gelernet, gilt auch von den Kunstwerken der Alten, sonderlich der Griechen. Man muß mit ihnen, wie mit seinem Freunde, bekannt geworden sein, um den Laokoon ebenso unnachahmlich als den Homer zu finden. In solcher genauen Bekanntschaft wird man wie Nikomachos von der Helena des Zeuxis urteilen: «Nimm meine Augen», sagte er zu einen Unwissenden, der das Bild tadeln wollte, «so wird sie dir eine Göttin scheinen.»

Mit diesem Auge haben Michelangelo, Raffael und Poussin die Werke der Alten angesehen. Sie haben den guten Geschmack aus seiner Quelle geschöpfet, und Raffael in dem Lande selbst, wo er sich gebildet. Man weiß, daß er junge Leute nach Griechenland geschicket, die Überbleibsel des Altertums für ihn zu zeichnen.

Eine Bildsäule von einer alten römischen Hand wird sich gegen ein griechisches Urbild allemal verhalten, wie Vergils Dido in ihrem Gefolge mit der Diana unter ihren Oreaden verglichen, sich gegen Homers Nausikaa verhält, welche jener nachzuahmen gesuchet hat.

Laokoon war den Künstlern im alten Rom ebendas, was er uns ist; des Polyklets Regel; eine vollkommene Regel der Kunst.

Ich habe nicht nötig anzuführen, daß sich in den berühmtesten Werken der griechischen Künstler gewisse Nachlässigkeiten finden: der Delphin, welcher der Mediceischen Venus zugegeben ist, nebst den spielenden Kindern; die Arbeit des Dioskurides außer der Hauptfigur in seinem geschnittenen Diomedes mit dem Palladio, sind Beispiele davon. Man weiß, daß die Arbeit der Rückseite auf den schönsten Münzen der ägyptischen und syrischen Könige den Köpfen dieser Könige selten beikommt. Große Künstler sind auch in ihren Nachlässigkeiten weise, sie können nicht fehlen, ohne zugleich zu unterrichten. Man betrachte ihre Werke, wie Lukian den Jupiter des Phidias will betrachtet haben; den Jupiter selbst, nicht den Schemel seiner Füße.

search means going to Athens; and Dresden will from now on be an Athens for artists.

The only way for us to become great or, if this be possible, inimitable, is to imitate the ancients. What someone once said of Homer—that to understand him well means to admire him—is also true for the art works of the ancients, especially the Greeks. One must become as familiar with them as with a friend in order to find their statue of Laocoon[4] just as inimitable as Homer. In such close acquaintance one learns to judge as Nicomachus judged Zeuxis' Helena: "Behold her with my eyes", he said to an ignorant person who found fault with this work of art, "and she will appear a goddess to you."

With such eyes did Michelangelo, Raphael, and Poussin see the works of the ancients. They partook of good taste at its source, and Raphael did this in the very land where it had begun. We know that he sent young artists to Greece in order to sketch for him the relics of antiquity.

The relationship between an ancient Roman statue and a Greek original will generally be similar to that seen in Virgil's imitation of Homer's Nausicaa, in which he compares Dido and her followers to Diana in the midst of her Oreads.[5]

Laocoon was for the artist of old Rome just what he is for us—the demonstration of Polyclitus' rules, the perfect rules of art.[6]

I need not remind the reader that certain negligences can be discovered in even the most famous works of Greek artists. Examples are the dolphin which was added to the Medicean Venus[7] together with the playing children; and the work of Dioscorides, except the main figure, in his cameo of Diomedes[8] with the Palladium. It is well known that the workmanship on the reverse of the finest coins of the kings of Syria and Egypt rarely equals that of the heads of these kings portrayed on the obverse. But great artists are wise even in their faults. They cannot err without teaching. One should observe their works as Lucian would have us observe the Jupiter of Phidias: as Jupiter himself, not his footstool.

Die Kenner und Nachahmer der griechischen Werke finden in ihren Meisterstücken nicht allein die schönste Natur, sondern noch mehr als Natur, das ist, gewisse idealische Schönheiten derselben, die, wie uns ein alter Ausleger des Plato lehret, von Bildern bloß im Verstande entworfen, gemacht sind.

Der schönste Körper unter uns wäre vielleicht dem schönsten griechischen Körper nicht ähnlicher, als Iphikles dem Herkules, seinem Bruder, war. Der Einfluß eines sanften und reinen Himmels würkte bei der ersten Bildung der Griechen, die frühzeitigen Leibesübungen aber gaben dieser Bildung die edle Form. Man nehme einen jungen Spartaner, den ein Held mit einer Heldin gezeuget, der in der Kindheit niemals in Windeln eingeschränkt gewesen, der von dem siebenden Jahre an auf der Erde geschlafen, und im Ringen und Schwimmen von Kindesbeinen an war geübet worden. Man stelle ihn neben einen jungen Sybariten unserer Zeit, und alsdenn urteile man, welchen von beiden der Künstler zu einem Urbilde eines jungen Theseus, eines Achilles, ja selbst eines Bacchus, nehmen würde. Nach diesem gebildet, würde es ein Theseus bei Rosen, und nach jenem gebildet, ein Theseus bei Fleisch erzogen, werden, wie ein griechischer Maler von zwo verschiedenen Vorstellungen dieses Helden urteilete.

Zu den Leibsübungen waren die großen Spiele allen jungen Griechen ein kräftiger Sporn, und die Gesetze verlangeten eine zehenmonatliche Vorbereitung zu den Olympischen Spielen, und dieses in Elis, an dem Orte selbst, wo sie gehalten wurden. Die größten Preise erhielten nicht allezeit Männer, sondern mehrenteils junge Leute, wie Pindars Oden zeigen. Dem göttlichen Diagoras gleich zu werden, war der höchste Wunsch der Jugend.

Sehet den schnellen Indianer an, der einem Hirsche zu Fuße nachsetzet: wie flüchtig werden seine Säfte, wie biegsam und schnell werden seine Nerven und Muskeln, und wie leicht wird der ganze Bau des Körpers gemacht. So bildet uns Homer seine Helden, und seinen Achilles bezeichnet er vorzüglich durch die Geschwindigkeit seiner Füße.

Die Körper erhielten durch diese Übungen den großen und männlichen Kontur, welchen die griechischen Meister ihren Bildsäulen gegeben, ohne Dunst und überflüssigen

Ansatz. Die jungen Spartaner mußten sich alle zehen Tage vor den Ephoren nackend zeigen, die denjenigen, welche anfingen fett zu werden, eine strengere Diät auflegten. Ja es war eins unter den Gesetzen des Pythagoras, sich vor allen überflüssigen Ansatz des Körpers zu hüten. Es geschahe vielleicht aus ebendem Grunde, daß jungen Leuten unter den Griechen der ältesten Zeiten, die sich zu einem Wettkampf im Ringen angaben, während der Zeit der Vorübungen nur Milchspeise zugelassen war.

Aller Übelstand des Körpers wurde behutsam vermieden, und da Alkibiades in seiner Jugend die Flöte nicht wollte blasen lernen, weil sie das Gesicht verstellte, so folgeten die jungen Athenienser seinem Beispiele.

Nach dem war der ganze Anzug der Griechen so beschaffen, daß er der bildenden Natur nicht den geringsten Zwang antat. Der Wachstum der schönen Form litte nichts durch die verschiedenen Arten und Teile unserer heutigen pressenden und klemmenden Kleidung, sonderlich am Halse, an Hüften und Schenkeln. Das schöne Geschlecht selbst unter den Griechen wußte von keinem ängstlichen Zwange in ihrem Putze: Die jungen Spartanerinnen waren so leicht und kurz bekleidet, daß man sie daher Hüftzeigerinnen nannte.

Es ist auch bekannt, wie sorgfältig die Griechen waren, schöne Kinder zu zeugen. Quillet in seiner Callipädie zeiget nicht so viel Wege dazu, als unter ihnen üblich waren. Sie gingen sogar so weit, daß sie aus blauen Augen schwarze zu machen suchten. Auch zu Beförderung dieser Absicht errichtete man Wettspiele der Schönheit. Sie wurden in Elis gehalten: der Preis bestand in Waffen, die in den Tempel der Minerva aufgehänget wurden. An gründlichen und gelehrten Richtern konnte es in diesen Spielen nicht fehlen, da die Griechen, wie Aristoteles berichtet, ihre Kinder im Zeichnen unterrichten ließen, vornehmlich weil sie glaubten, daß es geschickter mache, die Schönheit in den Körpern zu betrachten und zu beurteilen.

Das schöne Geblüt der Einwohner der mehresten griechischen Inseln, welches gleichwohl mit so verschiedenen fremden Geblüte vermischet ist, und die vorzüglichen Reizungen des schönen Geschlechts daselbst, sonderlich auf der Insel Skios, geben zugleich eine gegründete Mutmaßung von den Schönheiten beiderlei

In the masterpieces of Greek art, connoisseurs and imitators find not only nature at its most beautiful but also something beyond nature, namely certain ideal forms of its beauty, which, as an ancient interpreter of Plato[9] teaches us, come from images created by the mind alone.

The most beautiful body of one of us would probably no more resemble the most beautiful Greek body than Iphicles resembled his brother, Hercules.[10] The first development of the Greeks was influenced by a mild and clear sky; but the practice of physical exercises from an early age gave this development its noble forms. Consider, for example, a young Spartan conceived by a hero and heroine and never confined in swaddling clothes, sleeping on the ground from the seventh year on and trained from infancy in wrestling and swimming. Compare this Spartan with a young Sybarite[11] of our time and then decide which of the two would be chosen by the artist as a model for young Theseus, Achilles, or even Bacchus. Modelled from the latter it would be a Theseus fed on roses, while from the former would come a Theseus fed on flesh, to borrow the terms used by a Greek painter to characterize two different conceptions of this hero.

The grand games gave every Greek youth a strong incentive for physical exercise, and the laws demanded a ten-month preparation period for the Olympic Games, in Elis,[12] at the very place where they were held. The highest prizes were not always won by adults but often by youths, as told in Pindar's odes. To resemble the god-like Diagoras was the fondest wish of every young man.[13]

Behold the swift Indian who pursues a deer on foot—how briskly his juices must flow, how flexible and quick his nerves and muscles must be, how light the whole structure of his body! Thus did Homer portray his heroes, and his Achilles he chiefly noted as being "swift of foot".

These exercises gave the bodies of the Greeks the strong and manly contours which the masters then imparted to their statues without any exaggeration or excess.

The young Spartans had to appear naked every ten days before the Ephors,[14] who would impose a stricter diet upon those showing signs of fat. Indeed, one of the rules of Pythagoras was a warning against any corpulence. For the same reason perhaps, young Greeks in the earliest times, aspiring to compete in a wrestling contest, were confined to a diet of cereal and milk during their training period.

Any abuse of the body was carefully avoided. The young Athenians followed the example of Alcibiades, who in his youth refused to blow the flute for fear of distorting his face.

Accordingly, all clothing of the Greeks was so designed that it put not the slightest constraint upon formative nature. The development of beautiful form would not have permitted the different types and shapes of our present-day clothing, which binds and confines, especially at the neck, the hips, and the thighs. Among the Greeks the fair sex itself knew no anxious compulsions of dress. Young Spartan women wore such light and short garments that they were called "hip-barers".

We also know that the Greeks took great pains to conceive beautiful children. Quillet in his *Callipaedia*[15] does not show as many ways to that end as were customary among the Greeks. They even went so far as to try to change blue eyes into black. Beauty contests were organized to further their purpose. These were held in Elis, and the prizes consisted of weapons which were then hung in the temple of Minerva. There could be no dearth of competent and learned judges for these contests, since, as Aristotle reports, the Greeks trained their children in the art of drawing chiefly because they believed that this would heighten their skills in observing and judging physical beauty.

The handsome lineage of the inhabitants of most Greek islands—although mixed with the blood of many foreign races—and the outstanding charms of the fair sex, especially on the island of Chios, permit a reasonable conjecture as to the beauty of both sexes among their

Geschlechts unter ihren Vorfahren, die sich rühmeten, ursprünglich, ja älter als der Mond zu sein.

Es sind ja noch itzo ganze Völker, bei welchen die Schönheit sogar kein Vorzug ist, weil alles schön ist. Die Reisebeschreiber sagen dieses einhellig von den Georgiern, und ebendieses berichtet man von den Kabardinski, einer Nation in der krimischen Tatarei.

Die Krankheiten, welche so viel Schönheiten zerstören, und die edelsten Bildungen verderben, waren den Griechen noch unbekannt. Es findet sich in den Schriften der griechischen Ärzte keine Spur von Blattern, und in keines Griechen angezeigter Bildung, welche man beim Homer oft nach den geringsten Zügen entworfen siehet, ist ein so unterschiedenes Kennzeichen, dergleichen Blattergruben sind, angebracht worden.

Die venerischen Übel, und die Tochter derselben, die englische Krankheit, wüteten auch noch nicht wider die schöne Natur der Griechen.

Überhaupt war alles, was von der Geburt bis zur Fülle des Wachstums zur Bildung der Körper, zur Bewahrung, zur Ausarbeitung und zur Zierde dieser Bildung durch Natur und Kunst eingeflößet und gelehret worden, zum Vorteil der schönen Natur der alten Griechen gewürkt und angewendet, und kann die vorzügliche Schönheit ihrer Körper vor den unsrigen mit der größten Wahrscheinlichkeit zu behaupten Anlaß geben.

Die vollkommensten Geschöpfe der Natur aber würden in einem Lande, wo die Natur in vielen ihrer Wirkungen durch strenge Gesetze gehemmet war, wie in Ägypten, dem vorgegebenen Vaterlande der Künste und Wissenschaften, den Künstlern nur zum Teil und unvollkommen bekanntgeworden sein. In Griechenland aber, wo man sich der Lust und Freude von Jugend auf weihete, wo ein gewisser heutiger bürgerlicher Wohlstand der Freiheit der Sitten niemals Eintrag getan, da zeigte sich die schöne Natur unverhüllet zum großen Unterrichte der Künstler.

Die Schule der Künstler war in den Gymnasien, wo die jungen Leute, welche die öffentliche Schamhaftigkeit bedeckte, ganz nackend ihre Leibesübungen trieben. Der Weise, der Künstler gingen dahin: Sokrates den Charmides, den Autolykos, den Lysis zu lehren; ein Phidias, aus diesen schönen Geschöpfen seine Kunst zu bereichern.

10

ancestors, who boasted that they were original beings even more ancient than the moon.

Even now there are entire nations for whom beauty is no advantage, since everybody there is beautiful. Travelers unanimously report this of the Caucasian Georgians as well as of the Kabardians in the Crimea.[16]

Those illnesses which destroy so much beauty and impair the noblest forms were still unknown to the Greeks. In the writings of the Greek physicians there is no hint of smallpox, and in none of the descriptions of Greeks, carried out to the finest detail in Homer, is there any mention of distinguishing marks such as those of smallpox. The venereal diseases and their daughter, the English malady, had not yet wreaked their havoc on the beauty of the Greeks.

Moreover, everything that was instilled and taught from birth to adulthood about the culture of their bodies and the preservation, development, and refinement of this culture through nature and art was done to enhance the natural beauty of the ancient Greeks. Thus we can say in all probability that their physical beauty excelled ours by far.

The most perfect creations of nature would, on the other hand, have become only partially and imperfectly known to the artists in a country where nature was hindered by rigid laws, as in Egypt, the reputed home of the arts and sciences. In Greece, however, where people dedicated themselves to joy and pleasure from childhood on, and where there was no such social decorum as ours to restrict the freedom of their customs, the beauty of nature could reveal itself unveiled as a great teacher of artists.

The schools for artists were the gymnasia,[17] where young people, otherwise clothed for the sake of public modesty, performed their physical exercises in the nude. The philosopher and the artist went there—Socrates to teach Charmides, Autolycus, and Lysias; Phidias to enrich his art by watching these handsome young men. There one

Man lernete daselbst Bewegungen der Muskeln, Wendungen des Körpers: man studierte die Umrisse der Körper, oder den Kontur an dem Abdrucke, den die jungen Ringer im Sande gemacht hatten.

Das schönste Nackende der Körper zeigte sich hier in so mannigfaltigen, wahrhaften und edlen Ständen und Stellungen, in die ein gedungenes Modell, welches in unseren Akademien aufgestellet wird, nicht zu setzen ist.

Die innere Empfindung bildet den Charakter der Wahrheit, und der Zeichner, welche seinen Akademien denselben geben will, wird nicht einen Schatten des Wahren erhalten, ohne eigene Ersetzung desjenigen, was eine ungerührte und gleichgültige Seele des Modells nicht empfindet, noch durch eine Aktion, die einer gewissen Empfindung oder Leidenschaft eigen ist, ausdrücken kann.

Der Eingang zu vielen Gesprächen des Plato, die er in den Gymnasien zu Athen ihren Anfang nehmen lassen, machet uns ein Bild von den edlen Seelen der Jugend, und lässet uns auch hieraus auf gleichförmige Handlungen und Stellungen an diesen Orten und in ihren Leibesübungen schließen.

Die schönsten jungen Leute tanzten unbekleidet auf dem Theater, und Sophokles, der große Sophokles, war der erste, der in seiner Jugend dieses Schauspiel seinen Bürgern machte. Phryne badete sich in den Eleusinischen Spielen vor den Augen aller Griechen, und wurde beim Heraussteigen aus dem Wasser den Künstlern das Urbild einer Venus Anadyomene; und man weiß, daß die jungen Mädchen in Sparta an einem gewissen Feste ganz nackend vor den Augen der jungen Leute tanzten. Was hier fremde scheinen könnte, wird erträglicher werden, wenn man bedenket, daß auch die Christen der ersten Kirche ohne die geringste Verhüllung, sowohl Männer als Weiber, zu gleicher Zeit und in einem und ebendemselben Taufsteine getauft, oder untergetaucht worden sind.

Also war auch ein jedes Fest bei den Griechen eine Gelegenheit für Künstler, sich mit der schönen Natur aufs genaueste bekanntzumachen.

Die Menschlichkeit der Griechen hatte in ihrer blühenden Freiheit keine blutigen Schauspiele einführen wollen, oder wenn dergleichen in dem Ionischen Asien, wie einige glauben, üblich gewesen, so waren sie seit geraumer

could study the movement of the muscles and body as well as the body's outlines or contours from the impressions left by the young wrestlers in the sand. The nude body in its most beautiful form was exhibited there in so many different, natural, and noble positions and poses not attainable today by the hired models of our art schools.

Truth springs from the feelings of the heart, and the modern artist who wants to impart truth to his works cannot preserve even a shadow of it unless he himself is able to replace that which the unmoved and indifferent soul of his model does not feel or is unable to express by actions appropriate to a certain sensation or passion.

Many of Plato's dialogues, beginning in the gymnasia of Athens, portray to us the noble souls of these youths and at the same time suggest a uniformity of action and outward carriage developed in these places and in their physical exercises.

The most beautiful young people danced nude in the theaters, and Sophocles, the great Sophocles, was the first who in his youth presented such dramas for his fellow-citizens. Phryne bathed before the eyes of all the Greeks during the Eleusinian Games,[18] and, as she emerged from the water, became for the artists the prototype of Venus Anadyomene.[19] It is also known that girls from Sparta danced completely naked before the eyes of the young people at certain festive occasions. What might seem strange to us here becomes more acceptable when considering that the early Christians, both men and women, were totally unclothed when they were submersed in the same baptismal font.[20]

Thus every festival of the Greeks was an opportunity for the artists to become intimately acquainted with the beauty of nature.

During this period of greatest freedom the humanity of the Greeks had rejected the introduction of bloody gladiatorial spectacles, or if, indeed, such spectacles had been customary in Ionic Asia,[21] as some commentators believe,

Zeit wiederum eingestellet. Antiochos Epiphanes, König in Syrien, verschrieb Fechter von Rom, und ließ den Griechen Schauspiele dieser unglücklichen Menschen sehen, die ihnen anfänglich ein Abscheu waren: mit der Zeit verlor sich das menschliche Gefühl, und auch diese Schauspiele wurden Schulen der Künstler. Ein Ctesilas studierte hier seinen sterbenden Fechter, «an welchem man sehen konnte, wieviel von seiner Seele noch in ihm übrig war.»

Diese häufigen Gelegenheiten zur Beobachtung der Natur veranlasseten die griechischen Künstler noch weiter zu gehen: sie fingen an, sich gewisse allgemeine Begriffe von Schönheiten sowohl einzelner Teile als ganze Verhältnisse der Körper zu bilden, die sich über die Natur selbst erheben sollten; ihr Urbild war eine bloß im Verstande entworfene geistige Natur.

So bildete Raffael seine Galatea. Man sehe seinen Brief an den Grafen Baldassare Castiglione: «Da die Schönheiten», schreibt er, «unter dem Frauenzimmer so selten sind, so bediene ich mich einer gewissen Idee in meiner Einbildung.»

Nach solchen über die gewöhnliche Form der Materie erhabenen Begriffen bildeten die Griechen Götter und Menschen. An Göttern und Göttinnen machte Stirn und Nase beinahe eine gerade Linie. Die Köpfe berühmter Frauen auf griechischen Münzen haben dergleichen Profil, wo es gleichwohl nicht willkürlich war, nach idealischen Begriffen zu arbeiten. Oder man könnte mutmaßen, daß diese Bildung den alten Griechen ebenso eigen gewesen, als es bei den Kalmücken die flachen Nasen, bei den Chinesen die kleinen Augen sind. Die großen Augen der griechischen Köpfe auf Steinen und Münzen könnten diese Mutmaßung unterstützen.

Die römischen Kaiserinnen wurden von den Griechen auf ihren Münzen nach eben diesen Ideen gebildet: der Kopf einer Livia und einer Agrippina hat ebendasselbe Profil, welches der Kopf einer Artemisia und einer Kleopatra hat.

Bei allen diesen bemerket man, daß das von den Thebanern ihren Künstlern vorgeschriebene Gesetz: «die Natur bei Strafe aufs beste nachzuahmen» auch von andern Künstlern in Griechenland als ein Gesetz beobachtet worden. Wo das sanfte griechische Profil ohne

they had long since ceased. Antiochus Epiphanes, king of Syria, brought gladiators from Rome and had these unfortunate men engage in contests for the Greeks, who initially found them abhorrent; but time dulled the human feelings and these events also became schools for the artist. There Ctesias studied his dying gladiator, in whom one could discern "how much life was still left in him".[22]

These frequent opportunities to observe nature prompted Greek artists to go still further. They began to form certain general ideas of the beauty of individual parts of the body as well as of the whole—ideas which were to rise above nature itself; their model was an ideal nature originating in the mind alone.

Thus did Raphael conceive Galatea, as we can see in his letter to Count Baldassare Castiglione: "Since beauty is so rare among women, I avail myself of an ideal image."[23]

Following such concepts the Greeks gave their gods and men forms that transcended the common shapes of matter. In their figures of gods and goddesses, the forehead and nose formed nearly a straight line. Similar profiles of famous women can be seen on Greek coins, which were intentionally modelled after idealized concepts. Perhaps this profile was as peculiar to the ancient Greeks as flat noses are to the Kalmucks, and small eyes to the Chinese. The large eyes of the Greek faces on gems and coins tend to support this supposition. The Roman empresses depicted on coins by the Greek artists were similarly conceived; the head of Livia or of Agrippina has exactly the same profile as that of Artemisia or Cleopatra.

We observe, nevertheless, that the law prescribed by the Thebans to their artists—"To imitate nature as best as you can or suffer penalty"—was also obeyed by artists in other parts of Greece. In cases where the smooth Greek profile could not be used without endangering the resem-

Nachteil der Ähnlichkeit nicht anzubringen war, folgeten sie der Wahrheit der Natur, wie an den schönen Kopf der Julia, Kaisers Titus Tochter, von der Hand des Euodos zu sehen ist.

Das Gesetz aber, «die Personen ähnlich und zu gleicher Zeit schöner zu machen», war allezeit das höchste Gesetz, welches die griechischen Künstler über sich erkannten, und setzet notwendig eine Absicht des Meisters auf eine schönere und vollkommenere Natur voraus. Polygnotos hat dasselbe beständig beobachtet.

Wenn als von einigen Künstlern berichtet wird, daß sie wie Praxiteles verfahren, welcher seine Knidische Venus nach seiner Beischläferin Kratina gebildet, oder wie andere Maler, welche die Lais zum Modell der Grazien genommen, so glaube ich, sei es geschehen, ohne Abweichung von gemeldeten allgemeinen großen Gesetzen der Kunst. Die sinnliche Schönheit gab dem Künstler die schöne Natur; die idealische Schönheit die erhabenen Züge: von jener nahm er das Menschliche, von dieser das Göttliche.

Hat jemand Erleuchtung genug, in das Innerste der Kunst hineinzuschauen, so wird er durch Vergleichung des ganzen übrigen Baues der griechischen Figuren mit den mehresten neuen, sonderlich in welchen man mehr der Natur, als dem alten Geschmacke gefolget ist, vielmals noch wenig entdeckte Schönheiten finden.

In den meisten Figuren neuerer Meister siehet man an den Teilen des Körpers, welche gedruckt sind, kleine gar zu sehr bezeichnete Falten der Haut; dahingegen, wo sich ebendieselben Falten in gleichgedruckten Teilen griechischer Figuren legen, ein sanfter Schwung eine aus der andern wellenförmig erhebt, dergestalt, daß diese Falten nur ein Ganzes, und zusammen nur einen edlen Druck zu machen scheinen. Diese Meisterstücke zeigen uns eine Haut, die nicht angespannet, sondern sanft gezogen ist über ein gesundes Fleisch, welches dieselbe ohne schwülstige Ausdehnung füllet, und bei allen Beugungen der fleischigten Teile der Richtung derselben vereinigt folget. Die Haut wirft niemals, wie an unsern Körpern, besondere und von dem Fleisch getrennete kleine Falten.

Ebenso unterscheiden sich die neuern Werke von den griechischen durch eine Menge kleiner Eindrücke, und durch gar zu viele und gar zu sinnlich gemachte Grübchen,

blance, they followed nature, as can be seen in the beautiful head of Julia, the daughter of Emperor Titus, done by Euodus.[24]

The highest law recognized by Greek artists was "to create a just resemblance and at the same time a more handsome one"; it assumes of necessity that their goal was a more beautiful and more perfect nature. Polygnotus constantly observed this law.

Thus, when various artists reportedly followed the example of Praxiteles, who modeled his Cnidian Aphrodite after his mistress, Cratina, or of certain painters who took Lais as a model for the Graces, it is to be understood that this was done without neglecting the great and universal laws of art. Sensual beauty provided the artist with all that nature could give; ideal beauty provided him with sublimity—from the one he took the human element, from the other the divine.

A person enlightened enough to penetrate the innermost secrets of art will find beauties hitherto seldom revealed when he compares the total structure of Greek figures with most modern ones, especially those modelled more on nature than on Greek taste.

In most modern figures, where the skin on certain parts of the body is pressed, one can observe small but all too obvious individual wrinkles. In Greek figures, however, there is, in such a case, a gentle curvature of rippling folds coming one from the other in such a way that they appear as a whole and make but one noble impression. These masterpieces never display a skin tensely stretched, but rather, gently drawn over flesh which fills it firmly but without turgid protrusions, harmoniously following the directions of any flexions of the body. The skin never forms, as in modern bodies, individual small wrinkles distinct from the flesh beneath them.

Modern works are also distinguished from the Greek by their multitude of small indentations and much too visi-

welche, wo sie sich in den Werken der Alten befinden, mit einer sparsamen Weisheit, nach der Masse derselben in der vollkommenern und völligern Natur unter den Griechen, sanft angedeutet, und öfters nur durch ein gelehrtes Gefühl bemerket werden.

Es bietet sich hier allezeit die Wahrscheinlichkeit von selbst dar, daß in der Bildung der schönen griechischen Körper, wie in den Werken ihrer Meister, mehr Einheit des ganzen Baues, eine edlere Verbindung der Teile, ein reicheres Maß der Fülle gewesen, ohne magere Spannungen und ohne viel eingefallene Höhlungen unserer Körper.

Man kann weiter nicht, als bis zur Wahrscheinlichkeit gehen. Es verdienet aber diese Wahrscheinlichkeit die Aufmerksamkeit unserer Künstler und Kenner der Kunst; und dieses um so viel mehr, da es notwendig ist, die Verehrung der Denkmale der Griechen von dem ihr von vielen beigemessenen Vorurteile zu befreien, um nicht zu scheinen, der Nachahmung derselben bloß durch den Moder der Zeit ein Verdienst beizulegen.

Dieser Punkt, über welchen die Stimmen der Künstler geteilet sind, erfoderte eine ausführlichere Abhandlung, als in gegenwärtiger Absicht geschehen können.

Man weiß, daß der große Bernini einer von denen gewesen, die den Griechen den Vorzug einer teils schönern Natur, teils idealischen Schönheit ihrer Figuren hat streitig machen wollen. Er war außerdem der Meinung, daß die Natur allen ihren Teilen das erforderliche Schöne zu geben wisse: die Kunst bestehe darin, es zu finden. Er hat sich gerühmet, ein Vorurteil abgeleget zu haben, worin er in Ansehung des Reizes der Mediceischen Venus anfänglich gewesen, den er jedoch nach einem mühsamen Studio bei verschiedenen Gelegenheiten in der Natur wahrgenommen.

Also ist es die Venus gewesen, welche ihn Schönheiten in der Natur entdecken gelehret, die er vorher allein in jener zu finden geglaubet hat, und die er ohne der Venus nicht würde in der Natur gesuchet haben. Folget nicht daraus, daß die Schönheit der griechischen Statuen eher zu entdecken ist, als die Schönheit in der Natur, und daß also jene rührender, nicht so sehr zerstreuet, sondern mehr in eins vereiniget, als es diese ist? Das Studium der Natur

ble dimples. In the works of the ancients, these are subtly distributed with sparing sagacity, of a size appropriate to the more perfect and complete nature of the Greeks, and often are discernible only to an educated eye.

The probability is that in the beautiful bodily forms of the Greeks as well as in the works of their masters there was a greater unity of the entire structure, a nobler connection of parts, and a greater fullness of form, without the emaciated tensions and depressions of our bodies.

We can, of course, do no more than establish a probability. But this probability deserves the attention of our artists and connoisseurs—all the more so since the veneration and imitation of Greek monuments of art is, regrettably, often prompted not by their quality but by prejudice attached to their great age.

This point, concerning which there is a difference of opinion among artists, would require a more detailed treatment than is possible in the present study.

It is known that the great Bernini was one of those who refused to grant the Greeks the virtue of portraying either a more perfect nature or an ideal beauty in their figures. He was, furthermore, of the opinion that nature was capable of bestowing on all its parts the necessary amount of beauty, and that the skill of art consisted in finding it. He prided himself in having to overcome his earlier prejudice concerning the charms of the Medicean Venus, since, after painstaking study, he had been able to perceive occasionally these very charms in nature.[25]

It was this Venus therefore that taught him to discover beauties in nature which he had previously seen only in the statue and which, without the Venus, he would not have sought in nature. Does it not follow then that the beauty of Greek statues is easier to discover than beauty in nature and that thus the former is more inspiring, less diffuse and more harmoniously united than the latter? So the study of

muß also wenigstens ein längerer und mühsamerer Weg zur Kenntnis des vollkommenen Schönen sein, als es das Studium der Antiken ist: und Bernini hätte jungen Künstlern, die er allezeit auf das Schönste in der Natur vorzüglich wies, nicht den kürzesten Weg dazu gezeiget.

Die Nachahmung des Schönen der Natur ist entweder auf einen einzelnen Vorwurf gerichtet, oder sie sammlet die Bemerkungen aus verschiedenen einzelnen, und bringet sie in eins. Jenes heißt eine ähnliche Kopie, ein Porträt machen; es ist der Weg zu holländischen Formen und Figuren. Dieses aber ist der Weg zum allgemeinen Schönen und zu idealischen Bildern desselben; und derselbe ist es, den die Griechen genommen haben. Der Unterschied aber zwischen ihnen und uns ist dieser: Die Griechen erlangeten diese Bilder, wären auch dieselben nicht von schönern Körpern genommen gewesen, durch eine tägliche Gelegenheit zur Beobachtung des Schönen der Natur, die sich uns hingegen nicht alle Tage zeiget, und selten so, wie sie der Künstler wünschet.

Unsere Natur wird nicht leicht einen so vollkommenen Körper zeugen, dergleichen der Antinous Admirandus hat, und die Idee wird sich über die mehr als menschlichen Verhältnisse einer schönen Gottheit in dem Vatikanischen Apollo, nichts bilden können: was Natur, Geist und Kunst hervorzubringen vermögend gewesen, lieget hier vor Augen.

Ich glaube, ihre Nachahmung könne lehren, geschwinder klug zu werden, weil sie hier in dem einen den Inbegriff desjenigen findet, was in der ganzen Natur ausgeteilet ist, und in dem andern, wie weit die schönste Natur sich über sich selbst kühn, aber weislich erheben kann. Sie wird lehren, mit Sicherheit zu denken und zu entwerfen, indem sie hier die höchsten Grenzen des menschlich und zugleich des göttlich Schönen bestimmt siehet.

Wenn der Künstler auf diesen Grund bauet, und sich die griechische Regel der Schönheit Hand und Sinne führen lässet, so ist er auf dem Wege, der ihn sicher zur Nachahmung der Natur führen wird. Die Begriffe des Ganzen, des Vollkommenen in der Natur des Altertums werden die Begriffe des Geteilten in unserer Natur bei ihm läutern und sinnlicher machen: er wird bei Entdeckung der

nature must be at best a longer and more difficult way to gain knowledge of perfect beauty than the study of antiquity, and Bernini, by directing young artists primarily toward the most beautiful in nature, was not showing them the shortest way.

The imitation of beauty in nature either directs itself toward a single object or it gathers observations of various individual objects and makes of them a whole. The first method means making a similar copy, a portrait; this leads to the forms and figures of the Dutch artists. The second, however, is the way to general beauty and to ideal images of it; and this was the way chosen by the Greeks. But the difference between them and us is that the Greeks could arrive at their portrayals, if not from more beautiful bodies, then from a daily opportunity to observe beauty in nature—an opportunity which we do not have every day, and rarely in the manner that an artist would desire.

Our nature will not easily bring forth such a perfect body as that of Antinoüs Admirandus[26] nor our minds conceive anything beyond the more than human proportions of a beautiful deity such as that of the Vatican Apollo.[27] What nature, genius, and art have been capable of producing is here revealed to us.

I believe that the imitation of the Greeks can teach us to become knowledgeable more quickly, for it shows us on the one hand the essence of what is otherwise dispersed through all of nature, and, on the other, the extent to which the most perfect nature can boldly, yet wisely, rise above itself. Imitation will teach the artist to think and to draw with confidence, since he finds established in it the highest limits of that which is both humanly and divinely beautiful.

If the artist builds upon this groundwork and allows the Greek rules of beauty to guide his hand and mind, he will be on the path which will lead him safely to the imitation of nature. The concepts of unity and completeness in the nature of antiquity will purify and make more meaningful the concepts of those things that are divided in our nature.

Schönheiten derselben diese mit dem vollkommenen Schönen zu verbinden wissen, und durch Hülfe der ihm beständig gegenwärtigen erhabenen Formen wird er sich selbst eine Regel werden.

Alsdenn und nicht eher kann er, sonderlich der Maler, sich der Nachahmung der Natur überlassen in solchen Fällen, wo ihm die Kunst verstattet von dem Marmor abzugehen, wie in Gewändern, und sich mehr Freiheit zu geben, wie Poussin getan; denn «derjenige, welcher beständig andern nachgehet, wird niemals voraus kommen, und welcher aus sich selbst nichts Gutes zu machen weiß, wird sich auch der Sachen von anderen nicht gut bedienen», wie Michelangelo sagt.

Seelen, denen die Natur hold gewesen,

quibus arte benigna
Et meliore luto finxit praecordia Titan,

haben hier den Weg vor sich offen, Originale zu werden.

In diesem Verstande ist es zu nehmen, wenn de Piles berichten will, daß Raffael zu der Zeit, da ihn der Tod übereilt, sich bestrebet habe, den Marmor zu verlassen, und der Natur gänzlich nachzugehen. Der wahre Geschmack des Altertums würde ihn auch durch die gemeine Natur hindurch beständig begleitet haben, und alle Bemerkungen in derselben würden bei ihm durch eine Art einer chymischen Verwandlung dasjenige geworden sein, was sein Wesen, seine Seele ausmachte.

Er würde vielleicht mehr Mannigfaltigkeit, größere Gewänder, mehr Kolorit, mehr Licht und Schatten seinen Gemälden gegeben haben: aber seine Figuren würden dennoch allezeit weniger schätzbar hierdurch, als durch den edlen Kontur, und durch die erhabene Seele, die er aus den Griechen hatte bilden lernen, gewesen sein.

Nichts würde den Vorzug der Nachahmung der Alten vor der Nachahmung der Natur deutlicher zeigen können, als wenn man zwei junge Leute nähme von gleich schönem Talente, und den einen das Altertum, den andern die bloße Natur studieren ließe. Dieser würde die Natur bilden, wie er sie findet: als ein Italiener würde er Figuren malen vielleicht wie Caravaggio; als ein Niederländer, wenn er glücklich ist, wie Jacob Jordaens: als ein Franzos, wie

By discovering their beauties he will be able to bring them into harmony with perfect beauty and, with the help of the noble forms that are constantly in his awareness, he will become a rule unto himself.

Only then can the artist, especially the painter, trust himself to imitate nature in those cases in which art permits him to depart from the marble, as in the depiction of garments, and to allow himself, as Poussin did, a greater freedom. Because, as Michelangelo said: "He who constantly follows others will never surpass them, and he who can create nothing of his own will make poor use of the skills of others."

Minds favored by Nature,

> quibus arte benigna
> Et meliore luto finxit praecordia Titan,[28]

find here the way to become originals.

This is the sense of de Piles' report that Raphael, at the time of his death, intended to abandon marble in order to follow nature alone. The true taste he found in antiquity would have accompanied him constantly also in his contemplation of common nature, and all his observations of it would have become, through a sort of chemical transformation, his own essence and soul. He would perhaps have given his paintings more variety, used fuller garments, more shades of color, more light and shadow, but, in the last analysis, his figures would have gained less value from all of this than from the noble contour and sublimity of soul that the Greeks had taught him to portray.

Nothing would demonstrate more clearly the advantages of the imitation of antiquity over the imitation of nature than to take two young people of equal talent and to have one of them study antiquity and the other nature alone. The latter would depict nature as he finds her; if he were an Italian he would perhaps paint figures like those of Caravaggio; or if he were Dutch, he might paint like Jacob Jordaens; if a Frenchmen, like Stella. The former, how-

Stella: jener aber würde die Natur bilden, wie sie es
verlanget, und Figuren malen, wie Raffael.

II. Kontur

Könnte auch die Nachahmung der Natur dem Künstler
alles geben, so würde gewiß die Richtigkeit im Kontur
durch sie nicht zu erhalten sein; diese muß von den
Griechen allein erlernet werden.

Der edelste Kontur vereiniget oder umschreibet alle
Teile der schönsten Natur und der idealischen Schönheiten
in den Figuren der Griechen; oder er ist vielmehr der
höchste Begriff in beiden. Euphranor, der nach des Zeuxis
Zeiten sich hervortat, wird vor den ersten gehalten, der
demselben die erhabenere Manier gegeben.

Viele unter den neuren Künstlern haben den
griechischen Kontur nachzuahmen gesuchet, und fast
niemanden ist es gelungen. Der große Rubens ist weit ent-
fernt von dem griechischen Umrisse der Körper, und in
denenjenigen unter seinen Werken, die er vor seiner Reise
nach Italien, und vor dem Studio der Antiken gemachet
hat, am weitesten.

Die Linie, welche das Völlige der Natur von dem
Überflüssigen derselben scheidet, ist sehr klein, und die
größten neueren Meister sind über diese nicht allezeit
greifliche Grenze auf beiden Seiten zu sehr abgewichen.
Derjenige, welcher einen ausgehungerten Kontur
vermeiden wollen, ist in die Schwulst verfallen; der diese
vermeiden wollen, in das Magere.

Michelangelo ist vielleicht der einzige, von dem man
sagen könnte, daß er das Altertum erreichet; aber nur in
starken muskulösen Figuren, in Körpern aus der
Heldenzeit; nicht in zärtlich jugendlichen, nicht in
weiblichen Figuren, welche unter seiner Hand zu
Amazonen geworden sind.

Der griechische Künstler hingegen hat seinen Kontur in
allen Figuren wie auf die Spitze eines Haars gesetzt, auch in
den feinsten und mühsamsten Arbeiten, dergleichen auf
geschnittenen Steinen ist. Man betrachte den Diomedes

ever, would depict nature as it should be, and would paint
figures like those of Raphael.

II. Contour

Even if the imitation of nature could supply the artist
with everything, it still could not teach him correct con-
tour, for this can be learned from the Greeks alone. The
noblest contour combines or encompasses in Greek figures
all parts of sublime nature and of ideal beauty, or, one
might say, it represents the highest concept of both.
Euphranor, who became prominent after the time of
Zeuxis, is said to have first created contour in the grand
manner.

Many of the moderns have tried to imitate Greek con-
tour but few have succeeded. The great Rubens is far from
having attained it, especially in his works completed before
his journey to Italy and his study of antique sculpture. The
line which separates completeness of nature from superflu-
ity is very narrow, and even the greatest of modern masters
have strayed too far on either side of this often indistinct
line. Those trying to avoid emaciated contour have fallen
prey to opulence while others, trying to avoid the latter,
fell prey to emaciation.

Michelangelo is perhaps the only one who may be said
to have equalled antiquity, but he did this only in his
strong, muscular figures, in bodies of the heroic age, and
not his delicate youthful figures or his females, who in his
hands became Amazons.

In contrast, the Greek artist balanced contour on a
hair's breadth in all his figures, even in his most delicate
and painstaking work, such as cameos. One need only
observe the figures of Diomedes and Perseus by Dioscor-

und den Perseus des Dioskurides; den Herkules mit der Iole von der Hand des Teukers, und bewundere die hier unnachahmlichen Griechen.

Parrhasios wird insgemein vor den Stärksten im Kontur gehalten.

Auch unter den Gewändern der griechischen Figuren herrschet der meisterhafte Kontur, als die Hauptabsicht des Künstlers, der auch durch den Marmor hindurch den schönen Bau seines Körpers wie durch ein koisches Kleid zeiget.

Die im hohen Stile gearbeitete Agrippina, und die drei Vestalen unter den Königlichen Antiken in Dresden, verdienen hier als große Muster angeführet zu werden. Agrippina ist vermutlich nicht die Mutter des Nero, sondern die ältere Agrippina, eine Gemahlin des Germanicus. Sie hat sehr viel Ähnlichkeit mit einer vorgegebenen stehenden Statue ebendieser Agrippina in dem Vorsaale der Bibliothek zu San Marco in Venedig. unsere ist eine sitzende Figur, größer als die Natur, mit gestütztem Haupte auf die rechte Hand. Ihre schönes Gesicht zeiget eine Seele, die in tiefen Betrachtungen versenkt, und vor Sorgen und Kummer gegen alle äußere Empfindungen fühllos scheinet. Man könnte mutmaßen, der Künstler habe die Heldin in dem betrübten Augenblick vorstellen wollen, da ihr die Verweisung nach der Insel Pandateria war angekündiget worden.

Die drei Vestalen sind unter einem doppelten Titel verehrungswürdig. Sie sind die ersten großen Entdeckungen von Herkulaneum: allein was sie noch schätzbarer macht, ist die große Manier in ihren Gewändern. In diesem Teile der Kunst sind sie alle drei, sonderlich aber diejenige, welche größer ist als die Natur, der Farnesischen Flora und anderen griechischen Werken vom ersten Range beizusetzen. Die zwo andern, groß wie die Natur, sind einander so ähnlich, daß sie von einer und ebenderselben Hand zu sein scheinen; sie unterscheiden sich allein durch die Köpfe, welche nicht von gleicher Güte sind. An dem besten Kopfe liegen die gekräuselten Haare nach Art der Furchen geteilt, von der Stirne an bis da wo sie hinten zusammengebunden sind. An dem andern Kopfe gehen die Haare glatt über den Scheitel, und die vordere gekräuselten Haare sind durch ein Band gesammlet und gebunden. Es

ides,[29] or of Hercules and Iole by Teukros,[30] in order to admire the inimitable Greeks. Parrhasius is generally considered to be the greatest master of contour.

Masterful contour prevails even in draped figures as the main purpose of Greek artists, who display the beautiful structure of the body through the marble as through the transparent Kosian cloth.[31]

Certain antique statues from the royal collection in Dresden deserve mention as great examples of this: an Agrippina done in the high style, and the three vestal virgins. This Agrippina is presumably not the mother of Nero but an older Agrippina, wife of Germanicus. She closely resembles another figure, assumed to be this latter Agrippina, in an upright pose, standing in the entrance hall of the library of San Marco's Church in Venice.[32] Ours is a sitting figure larger than life, her head resting on her right hand. Her beautiful face reflects a soul in deep contemplation, apparently oblivious to all external impressions because of her anxiety and grief. One might conjecture that the artist intended to portray the heroine at the sad moment when she heard of her banishment to the island of Pandateria.[33]

The vestals[34] are admirable for two reasons: They were the first great discoveries at Herculaneum, and, what makes them even more valuable, their garments were done in the grand manner. In this respect all three of them, but especially the one larger than life, are equal in quality to the Farnesian Flora and other Greek works of the highest order. The two others, which are life-sized, are so alike that they seem to have been created by the same hand; only their heads, of unequal quality, are different. The better head has curled hair divided into furrows, so to speak, from the forehead to the back of the head where the hair is gathered and tied. On the other one the hair is smooth at the crown, and the curled hair in front is gathered and

ist glaublich, daß dieser Kopf durch eine neuere wiewohl gute Hand gearbeitet und angesetzt worden.

Das Haupt dieser beiden Figuren ist mit keinem Schleier bedecket, welches ihnen aber den Titel der Vestalen nicht streitig machet; da erweislich ist, daß sich auch anderwärts Priesterinnen der Vesta ohne Schleier finden. Oder es scheinet vielmehr aus den starken Falten des Gewandes hinten am Halse, daß der Schleier, welcher kein abgesondertes Teil vom Gewande ist, wie an der größten Vestale zu sehen, hinten übergeschlagen liege.

Es verdienet der Welt bekanntgemacht zu werden, daß diese drei göttlichen Stücke die ersten Spuren gezeiget zur nachfolgenden Entdeckung der unterirdischen Schätze von der Stadt Herkulaneum.

Sie kamen an das Tagelicht, da annoch das Andenken derselben gleichsam unter der Vergessenheit, so wie die Stadt selbst, unter ihren eigenen Ruinen vergraben und verschüttet lag: zu der Zeit, da das traurige Schicksal, welches diesen Ort betroffen, nur fast noch allein durch des jüngern Plinius Nachricht von dem Ende seines Vetters, welches ihn in der Verwüstung von Herkulaneum zugleich mit übereilete, bekannt war.

Diese großen Meisterstücke der griechischen Kunst wurden schon unter den deutschen Himmel versetzet, und daselbst verehret, da Neapel noch nicht das Glück hatte, ein einziges herkulanisches Denkmal, soviel man erfahren können, aufzuweisen.

Sie wurden im Jahr 1706 in Portici bei Neapel in einem verschütteten Gewölbe gefunden, da man den Grund grub zu einem Landhause des Prinzen von Elbeuf, und sie kamen unmittelbar hernach, nebst andern daselbst entdeckten Statuen in Marmor und Erzt, in den Besitz des Prinzen Eugens nach Wien.

Dieser große Kenner der Künste, um einen vorzüglichen Ort zu haben, wo dieselben könnten aufgestellet werden, hat vornehmlich für diese drei Figuren eine Sala terrena bauen lassen, wo sie nebst einigen andern Statuen ihren Platz bekommen haben. Die ganze Akademie und alle Künstler in Wien waren gleichsam in Empörung, da man nur noch ganz dunkel von derselben Verkauf sprach, und ein jeder sahe denselben mit betrübten Augen

bound by a ribbon. It is conceivable that this head was added by a more modern, yet skilled, hand.

Although the heads of these two figures are not veiled, this does not disprove their identity as vestals, since we know that there are other priestesses of Vesta without a veil. Or rather it seems, judging from the large folds of the garment at the back of the neck, that the veil may be a part of the garment itself that has been thrown back; such a veil can be seen on the largest vestal.

All the world should be made aware that these three sublime statues revealed the first traces leading to the discovery of the buried treasures of Herculaneum.[35] They came to light at the time when all memory of them was still covered by the same cloak of oblivion as the city itself, under its own ruins. This was a time when its sad fate had been scarcely made known except by the younger Pliny's account of his uncle's sudden death during the destruction of Herculaneum.

These great masterpieces of Greek art were brought to Germany and honored there before Naples had the good fortune, as far as we know, of possessing a single relic of Herculaneum.

They were discovered in 1706 in Portici near Naples, in a collapsed vault laid bare during the excavations for a villa of the Prince d'Elbeuf. Very soon thereafter they were taken to Vienna, together with other marble and metal statues found in Portici, as possessions of Prince Eugene of Savoy. In order to display them to the best advantage, Prince Eugene, a great connoisseur of art, placed them, together with several other statues, in a *sala terrena*[36] built expressly for this purpose. When they were later taken to Dresden, the entire Academy and all the artists of Vienna reacted with dismay and sadness, since their sale had been only vaguely rumored.

nach, als sie von Wien nach Dresden fortgeführet wurden. Der berühmte Mattielli,

dem Polyklet das Maß, und Phidias das Eisen gab
<div align="right">ALGAROTTI</div>

hat, ehe noch dieses geschahe, alle drei Vestalen mit dem mühsamsten Fleiße in Ton kopieret, um sich den Verlust derselben dadurch zu ersetzen. Er folgete ihnen einige Jahre hernach, und erfüllete Dresden mit ewigen Werken seiner Kunst: aber seine Priesterinnen blieben auch hier sein Studium in der Draperie, worin seine Stärke bestand, bis in sein Alter; welches zugleich ein nicht ungegründetes Vorurteil ihrer Trefflichkeit ist.

III. Draperie

Unter dem Wort Draperie begreift man alles, was die Kunst von Bekleidung des Nackenden der Figuren und von gebrochenen Gewändern lehret. Diese Wissenschaft ist nach der schönen Natur, und nach dem edlen Kontur, der dritte Vorzug der Werke des Altertums.

Die Draperie der Vestalen ist in der höchsten Manier: die kleinen Brüche entstehen durch einen sanften Schwung aus den größeren Partien, und verlieren sich wieder in diesen mit einer edlen Freiheit und sanften Harmonie des Ganzen, ohne den schönen Kontur des Nackenden zu verstecken. Wie wenig neuere Meister sind in diesem Teile der Kunst ohne Tadel!

Diese Gerechtigkeit aber muß man einigen großen Künstlern, sonderlich Malern neuerer Zeiten, widerfahren lassen, daß sie in gewissen Fällen von dem Wege, den die griechischen Meister in Bekleidung ihrer Figuren am gewöhnlichsten gehalten haben, ohne Nachteil der Natur und Wahrheit abgegangen sind. Die griechische Draperie ist mehrenteils nach dünnen und nassen Gewändern gearbeitet, die sich folglich, wie Künstler wissen, dicht an die Haut und an den Körper schließen, und das Nackende desselben sehen lassen. Das ganze oberste Gewand des

The famous Matielli,

"to whom Policet gave his rule, and Phidias his chisel"
ALGAROTTI[37]

had painstakingly copied all three vestals in clay in order to compensate himself for their loss, and following them to Dresden a few years later he filled that city with eternal monuments of his art. But even there the priestesses were his models for drapery, which remained his chief skill until his last years—certainly a striking proof of their excellence.

III. Drapery

"Drapery" encompasses all that can be learned about the art of clothing naked figures and about the folds of such garments. This knowledge ranks after beautiful nature and noble contour as the third perogative of the works of antiquty.

The vestals are draped in the grand manner. The smaller folds emerge in gentle curves from the larger ones and disappear again in them with a noble freedom and gentle harmony of the whole, without concealing the beautiful contour of the nude body underneath. How few of the moderns would stand this test of their art!

However, in fairness to a few great artists, especially more modern painters, one must concede that they have at times deviated from the customary Grecian method of draping figures without doing violence to nature and truth. Greek drapery was usually modelled from thin and wet clothing which, as artists well know, clings to the skin and permits the naked outlines of the body to be seen. The en-

griechischen Frauenzimmers war ein sehr dünner Zeug; er hieß daher Peplon, ein Schleier.

Daß die Alten nicht allezeit fein gebrochene Gewänder gemacht haben, zeigen die erhabenen Arbeiten derselben. Die alten Malereien, und sonderlich die alten Brustbilder. Der schöne Caracalla unter den Königlichen Antiken in Dresden kann dieses bestätigen.

In den neuern Zeiten hat man ein Gewand über das andere, und zuweilen schwere Gewänder, zu legen gehabt, die nicht in so sanfte und fließende Brüche, wie der Alten ihre sind, fallen können. Dieses gab folglich Anlaß zu der neuen Manier der großen Partien in Gewändern, in welcher der Meister seine Wissenschaft nicht weniger, als in der gewöhnlichen Manier der Alten zeigen kann.

Carlo Maratta und Francesco Solimena können in dieser Art vor die Größten gehalten werden. Die neue Venezianische Schule, welche noch weiter zu gehen gesuchet, hat diese Manier übertrieben, und indem sie nichts als große Partien gesuchet, sind ihre Gewänder dadurch steif und blechern worden.

IV. Edle Einfalt und stille Grösse

Das allgemeine vorzügliche Kennzeichen der griechischen Meisterstücke ist endlich eine edle Einfalt, und eine stille Größe, sowohl in der Stellung als im Ausdrucke. So wie die Tiefe des Meers allezeit ruhig bleibt, die Oberfläche mag noch so wüten, ebenso zeiget der Ausdruck in den Figuren der Griechen bei allen Leidenschaften eine große und gesetzte Seele.

Diese Seele schildert sich in dem Gesichte des Laokoons, und nicht in dem Gesichte allein, bei dem heftigsten Leiden. Der Schmerz, welcher sich in allen Muskeln und Sehnen des Körpers entdecket, und den man ganz allein, ohne das Gesicht und andere Teile zu betrachten, an dem schmerzlich eingezogenen Unterleibe beinahe selbst zu empfinden glaubet; dieser Schmerz, sage ich, äußert sich dennoch mit keiner Wut in dem Gesichte und in der ganzen Stellung. Er erhebet kein schreckliches Geschrei, wie

tire outer garment of Greek women was of very thin material and therefore was called peplon, a "veil".

The ancients did not always portray clothing with fine folds, as is demonstrated in their reliefs, paintings, and particularly their busts. Among the royal antiquities in Dresden, the handsome Caracalla confirms this.

In more recent times the artist has been compelled to depict garments worn one on top of another, and at times heavy ones which could not hang in such light and flowing folds as those of the ancients. As a result a new method has been developed for handling large folds, by which the master can show his skill no less than in the customary manner of the ancients. Carlo Maratti and Francesco Solimena can be considered the greatest in this technique. The new Venetian School, however, went to an extreme by depicting nothing but massive folds, which give their garments a stiff and metallic appearance.

IV. Noble Simplicity and Quiet Grandeur

The general and most distinctive characteristics of the Greek masterpieces are, finally, a noble simplicity and quiet grandeur, both in posture and expression. Just as the depths of the sea always remain calm however much the surface may rage, so does the expression of the figures of the Greeks reveal a great and composed soul even in the midst of passion.

Such a soul is reflected in the face of Laocoon[38] — and not in the face alone — despite his violent suffering. The pain is revealed in all the muscles and sinews of his body, and we ourselves can almost feel it as we observe the painful contraction of the abdomen alone without regarding the face and other parts of the body. This pain, however, expresses itself with no sign of rage in his face or in his entire bearing. He emits no terrible screams such as Virgil's

Vergil von seinem Laokoon singet: Die Öffnung des
Mundes gestattet es nicht; es ist vielmehr ein ängstliches
und beklemmtes Seufzen, wie es Sadoleto beschreibet. Der
Schmerz des Körpers und die Größe der Seele sind durch
den ganzen Bau der Figur mit gleicher Stärke ausgeteilet,
und gleichsam abgewogen. Laokoon leidet, aber er leidet
wie des Sophokles Philoktet: sein Elend gehet uns bis an
die Seele; aber wir wünschten, wie dieser große Mann, das
Elend ertragen zu können.

Der Ausdruck einer so großen Seele gehet weit über die
Bildung der schönen Natur: Der Künstler mußte die Stärke
des Geistes in sich selbst fühlen, welche er seinem Marmor
einprägte. Griechenland hatte Künstler und Weltweisen in
einer Person, und mehr als einen Metrodor. Die Weisheit
reichte der Kunst die Hand, und blies den Figuren
derselben mehr als gemeine Seelen ein.

Unter einem Gewande, welches der Künstler dem
Laokoon als einem Priester hätte geben sollen, würde uns
sein Schmerz nur halb so sinnlich gewesen sein. Bernini hat
sogar den Anfang der Würkung des Gifts der Schlange in
dem einen Schenkel des Laokoons an der Erstarrung
desselben entdecken wollen.

Alle Handlungen und Stellungen der griechischen
Figuren, die mit diesem Charakter der Weisheit nicht
bezeichnet, sondern gar zu feurig und zu wild waren, ver-
fielen in einen Fehler, den die alten Künstler PARENTHYRSIS
nannten.

Je ruhiger der Stand des Körpers ist, desto geschickter
ist er, den wahren Charakter der Seele zu schildern: in allen
Stellungen, die von dem Stande der Ruhe zu sehr
abweichen, befindet sich die Seele nicht in dem Zustande,
der ihr der eigentlichste ist, sondern in einem gewaltsamen
und erzwungenen Zustande. Kenntlicher und bezeichnen-
der wird die Seele in heftigen Leidenschaften; groß aber
und edel ist sie in dem Stande der Einheit, in dem Stande
der Ruhe. Im Laokoon würde der Schmerz, allein gebildet,
PARENTHYRSIS gewesen sein; der Künstler gab ihm daher,
um das Bezeichnende und das Edle der Seele in eins zu
vereinigen, eine Aktion, die dem Stande der Ruhe in
solchem Schmerze der nächste war. Aber in dieser Ruhe
muß die Seele durch Züge, die ihr und keiner andern Seele
eigen sind, bezeichnet werden, um sie ruhig, aber zugleich

Laocoon, for the opening of his mouth does not permit it; it is rather an anxious and troubled sighing as described by Sadoleto.[39] The physical pain and the nobility of soul are distributed with equal strength over the entire body and are, as it were, held in balance with one another. Laocoon suffers, but he suffers like Sophocles' Philoctetes;[40] his pain touches our very souls, but we wish that we could bear misery like this great man.

The expression of such nobility of soul goes far beyond the depiction of beautiful nature. The artist had to feel the strength of this spirit in himself and then impart it to his marble. Greece had artists who were at once philosophers, and there was more than one Metrodorus.[41] Wisdom extended its hand to art and imbued its figures with more than common souls.

If the artist had clothed him, as would indeed befit his station as a priest, Laocoon's pain would have lost half its expression. Bernini even claimed to detect in the rigidity of one of Laocoon's thighs the first effects of the snake's venom.

All movements and poses of Greek figures not marked by such traits of wisdom, but instead by passion and violence, were the result of an error of conception which the ancient artists called *parenthyrsos*.[42]

The more tranquil the state of the body the more capable it is of portraying the true character of the soul. In all positions too removed from this tranquillity, the soul is not in its most essential condition, but in one that is agitated and forced. A soul is more apparent and distinctive when seen in violent passion, but it is great and noble when seen in a state of unity and calm. The portrayal of suffering alone in Laocoon would have been *parenthyrsos*; therefore the artist, in order to unite the distinctive and the noble qualities of soul, showed him in an action that was closest to a state of tranquillity for one in such pain. But in this tranquillity the soul must be distinguished by traits that are uniquely its own and give it a form that is calm and

wirksam, stille, aber nicht gleichgültig oder schläfrig zu bilden.

Das wahre Gegenteil, und das diesem entgegenstehende äußerste Ende ist der gemeinste Geschmack der heutigen, sonderlich angehenden Künstler. Ihren Beifall verdienet nichts, als worin ungewöhnliche Stellungen und Handlungen, die ein freches Feuer begleitet, herrschen, welches sie mit Geist, mit Franchezza, wie sie reden, ausgeführet heißen. Der Liebling ihrer Begriffe ist der Kontrapost, der bei ihnen der Inbegriff aller selbstgebildeten Eigenschaften eines vollkommenen Werks der Kunst ist. Sie verlangen eine Seele in ihren Figuren, die wie ein Komet aus ihrem Kreise weichet; sie wünschten in jeder Figur einen Ajax und einen Kapaneus zu sehen.

Die schönen Künste haben ihre Jugend so wohl, wie die Menschen, und der Anfang dieser Künste scheinet wie der Anfang bei Künstlern gewesen zu sein, wo nur das Hochtrabende, das Erstaunende gefällt. Solche Gestalt hatte die tragische Muse des Aischylos, und sein Agamemnon ist zum Teil durch Hyperbolen viel dunkler geworden, als alles, was Heraklit geschrieben. Vielleicht haben die ersten griechischen Maler nicht anders gezeichnet, als ihr erster guter Tragicus gedichtet hat.

Das Heftige, das Flüchtige gehet in allen menschlichen Handlungen voran; das Gesetzte, das Gründliche folget zuletzt. Dieses letztere aber gebrauchet Zeit, es zu bewundern; es ist nur großen Meistern eigen: heftige Leidenschaften sind ein Vorteil auch für ihre Schüler.

Die Weisen in der Kunst wissen, wie schwer dieses scheinbare Nachahmliche ist

<div align="right">ut sibi quivis</div>

Speret idem, sudet multum frustraque laboret
Ausus idem.

<div align="right">HOR.</div>

Lafage, der große Zeichner hat den Geschmack der Alten nicht erreichen können. Alles ist in Bewegung in seinen Werken, und man wird in der Betrachtung derselben geteilet und zerstreuet, wie in einer Gesellschaft, wo alle Personen zugleich reden wollen.

Die edle Einfalt und stille Größe der griechischen Statuen ist zugleich das wahre Kennzeichen der griechischen

active at the same time, quiet but not indifferent or sluggish.

The common taste of artists of today, especially the younger ones, is in complete opposition to this. Nothing gains their approbation but contorted postures and actions in which bold passion prevails. This they call art executed with spirit, or *franchezza*.[43] Their favorite term is *contrapposto*,[44] which represents for them the essence of a perfect work of art. In their figures they demand a soul which shoots like a comet out of their midst; they would like every figure to be an Ajax or a Capaneus.[45]

The arts themselves have their infancy as do human beings, and they begin as do youthful artists with a preference for amazement and bombast. Such was the tragic muse of Aeschylus; his hyperbole[46] makes his Agamemnon in part far more obscure than anything that Heraclitus wrote. Perhaps the first Greek painters painted in the same manner that their first good tragedian wrote.

Rashness and volatility lead the way in all human actions; steadiness and composure follow last. The latter, however, take time to be discovered and are found only in great matters; strong passions can be of advantage to their students. The wise artist knows how difficult these qualities are to imitate.

> ut sibi quivis
> Speret idem, sudet multum frustraque laboret
> Ausus idem.
>
> HORACE[47]

La Fage, the great draughtsman, was unable to match the taste of the ancients. His works are so full of movement that the observer's attention is at the same time attracted and distracted, as at a social gathering where everyone tries to talk at once.

The noble simplicity and guiet grandeur of the Greek statues is also the true hallmark of Greek writings from

Schriften aus den besten Zeiten, der Schriften aus Sokrates'
Schule; und diese Eigenschaften sind es, welche die
vorzügliche Größe eines Raffaels machen, zu welcher er
durch die Nachahmung der Alten gelanget ist.

Eine so schöne Seele, wie die seinige war, in einem so
schönen Körper wurde erfordert, den wahren Charakter
der Alten in neueren Zeiten zuerst zu empfinden und zu
entdecken, und was sein größtes Glück war, schon in
einem Alter, in welchem gemeine und halbgeformte Seelen
über die wahre Größe ohne Empfindung bleiben.

Mit einem Auge, welches diese Schönheiten empfinden
gelernet, mit diesem wahren Geschmacke des Altertums
muß man sich seinen Werken nähern. Alsdenn wird uns die
Ruhe und Stille der Hauptfiguren in Raffaels Attila, welche
vielen leblos scheinen, sehr bedeutend und erhaben sein.
Der römische Bischof, der das Vorhaben des Königs der
Hunnen, auf Rom loszugehen, abwendet, erscheinet nicht
mit Gebärden und Bewegungen eines Redners, sondern als
ein ehrwürdiger Mann, der bloß durch seine Gegenwart
einen Aufruhr stillet; wie derjenige, den uns Vergil
beschreibet,

> Tum pietate gravem ac meritis si forte virum quem
> Conspexere, silent arrectisque auribus adstant.
>
> AEN. I

mit einem Gesichte voll göttlicher Zuversicht vor den
Augen des Wüterichs. Die beiden Apostel schweben nicht
wie Würgeengel in den Wolken, sondern wenn es erlaubt
ist, das Heilige mit dem Unheiligen zu vergleichen, wie
Homers Jupiter, der durch das Winken seiner Augenlider
den Olymp erschüttern macht.

Algardi in seiner berühmten Vorstellung ebendieser
Geschichte in halb erhobener Arbeit, an einem Altar der St.
Peterskirche in Rom, hat die wirksame Stille seines großen
Vorgängers den Figuren seiner beiden Apostel nicht
gegeben, oder zu geben verstanden. Dort erscheinen sie wie
Gesandten des Herrn der Heerscharen: hier wie sterbliche
Krieger mit menschlichen Waffen.

Wie wenig Kenner hat der schöne St. Michael des
Guido in der Kapuzinerkirche zu Rom gefunden, welche
die Größe des Ausdrucks, die der Künstler seinem Erzengel
gegeben, einzusehen vermögend gewesen! Man gibt des

their best period, the writings of the Socratian school. And these are the best characteristics of Raphael's greatness, which he attained through imitation of the Greeks.

So great a soul in so handsome a body as Raphael's was needed to first feel and to discover in modern times the true character of the ancients. He had, furthermore, the great good fortune to achieve this at an age when ordinary and undeveloped souls are still insensitive to true greatness.

We must approach his works with the true taste of antiquity and with eyes that have learned to sense these beauties. Then the calm serenity of the main figures in Raphael's "Attila", which seem lifeless to many, will be for us most significant and noble. The Roman bishop here,[48] who dissuaded the king of the Huns from attacking Rome, does not make the gestures and movements of an orator but is shown rather as a man of dignity whose mere presence calms a violent spirit, as in Virgil's description:

> Tum pietate gravem ac meritis si forte virum quem
> Conspexere, silent arrectisque auribus adstant.
>
> AEN. I.[49]

Full of confidence he faces the raging tyrant, while the two apostles hovering in the clouds are not like avenging angels but, if I may compare the sacred with the profane, like Homer's Jupiter, who makes Mount Olympus quiver with a blink of his eyes.

Algardi, in his famous representation of this same story in bas-relief on an altar of St. Peter's in Rome, did not give or know how to give the figures of his two apostles the active tranquillity of his great predecessor. There they appeared like messengers of the lord of hosts, but here they are like mortal warriors with human weapons.

How few experts have been able to understand the grandeur of expression which Guido Reni gave his beautiful painting of Archangel Michael in the Church of

Conca seinem Michael den Preis vor jenen, weil er Unwillen und Rache im Gesichte zeiget, anstatt daß jener, nachdem er den Feind Gottes und der Menschen gestürzt, ohne Erbitterung mit einer heiteren und ungerührten Miene über ihn schwebet.

Ebenso ruhig und stille malet der englische Dichter den rächenden Engel, der über Britannien schwebet, mit welchem er den Helden seines FELDZUGS, den Sieger bei Blenheim vergleichet.

Die Königliche Galerie der Schildereien in Dresden enthält nunmehro unter ihren Schätzen ein würdiges Werk von Raffaels Hand, und zwar von seiner besten Zeit, wie Vasari und andere mehr bezeugen. Eine Madonna mit dem Kinde, dem hl. Sixtus und der hl. Barbara, kniend auf beiden Seiten, nebst zwei Engeln im Vorgrunde.

Es war dieses Bild das Hauptaltarblatt des Klosters St. Sixti in Piacenza. Liebhaber und Kenner der Kunst gingen dahin, um diesen Raffael zu sehen, so wie man nur allein nach Thespiä reisete, den schönen Cupido von der Hand des Praxiteles daselbst zu betrachten.

Sehet die Madonna mit einem Gesichte voll Unschuld und zugleich einer mehr als weiblichen Größe, in einer selig ruhigen Stellung, in derjenigen Stille, welche die Alten in den Bildern ihrer Gottheiten herrschen ließen. Wie groß und edel ist ihr ganzer Kontur!

Das Kind auf ihren Armen ist ein Kind über gemeine Kinder erhaben, durch ein Gesichte, aus welchem ein Strahl der Gottheit durch die Unschuld der Kindheit hervorzuleuchten scheinet.

Die Heilige unter ihr kniet ihr zur Seiten in einer anbetenden Stille ihrer Seelen, aber weit unter der Majestät der Hauptfigur; welche Erniedrigung der große Meister durch den sanften Reiz in ihrem Gesichte ersetzet hat.

Der Heilige dieser Figur gegenüber ist der ehrwürdigste Alte mit Gesichtszügen, die von seiner Gott geweiheten Jugend zu zeugen scheinen.

Die Ehrfurcht der hl. Barbara gegen die Madonna, welche durch ihre an die Brust gedrückten schönen Hände sinnlicher und rührender gemacht ist, hilft bei dem Heiligen die Bewegung seiner einen Hand ausdrücken. Ebendiese Aktion malet uns die Entzückung des Heiligen, welche der Künstler zu mehrerer Mannigfaltigkeit,

the Capuchins in Rome. Concha's St. Michael[50] is preferred because his face shows anger and revenge, whereas Guido's archangel, after casting down the enemy of God and man, hovers over him without bitterness, his expression calm and serene.

Just as calm and serene is the avenging hovering angel with whom the English poet compares the victorious commander at Blenheim as protector of Britannia.[51]

The Royal Gallery of Paintings in Dresden now contains among its treasures one of Raphael's best works, as Vasari and others have noted. It is a Madonna and Child with St. Sixtus and Saint Barbara kneeling on each side, and two angels in the foreground.[52] This picture was the central altar piece at the monastery of St. Sixtus in Piacenza. Art lovers and connoisseurs went to see this Raphael just as people traveled to Thespiae[53] solely to see Praxiteles' beautiful statue of Cupid.

Behold this Madonna, her face filled with innocence and extraordinary greatness, in a posture of blissful serenity! It is the same serenity with which the ancients imbued the depictions of their deities. How awesome and noble is her entire contour! The child in her arms is a child elevated above ordinary children; in its face a divine radiance illuminates the innocence of childhood. Saint Barbara kneels in worshipful stillness at her side, but far beneath the majesty of the main figure—in a humility for which the great master found compensation in the gentle charm of her expression. Saint Sixtus, kneeling opposite her, is a venerable old man whose features bear witness to his youth devoted to God.

Saint Barbara's reverence for the Madonna, which is made more vivid and moving by the manner in which she presses her beautiful hands to her breast, helps to support the gesture which Saint Sixtus makes with his hand. This gesture of ecstasy was chosen by the artist to add variety to

weislicher der männlichen Stärke, als der weiblichen Züchtigkeit geben wollen.

Die Zeit hat allerdings vieles von dem scheinbaren Glanze dieses Gemäldes geraubet, und die Kraft der Farben ist zum Teil ausgewittert; allein die Seele, welche der Schöpfer dem Werke seiner Hände eingeblasen, belebet es noch itzo.

Alle diejenigen, welche zu diesem und andern Werken Raffaels treten, in der Hoffnung, die kleinen Schönheiten anzutreffen, die den Arbeiten der niederländischen Maler einen so hohen Preis geben; den mühsamen Fleiß eines Netschers, oder eines Dou, das elfenbeinerne Fleisch eines van der Werff, oder auch die geleckte Manier einiger von Raffaels Landesleuten unserer Zeit; diese, sage ich, werden den großen Raffael in dem Raffael vergebens suchen.

V. Arbeitsmethoden

Nach dem Studio der schönen Natur, des Konturs, der Draperie, und der edlen Einfalt und stillen Größe in den Werken griechischer Meister, wäre die Nachforschung über ihre Art zu arbeiten ein nötiges Augenmerk der Künstler, um in der Nachahmung derselben glücklicher zu sein.

Es ist bekannt, daß sie ihre ersten Modelle mehrenteils in Wachs gemachet haben; die neuern Meister aber haben an dessen Statt Ton oder dergleichen geschmeidige Massen gewählet: sie fanden dieselben, sonderlich das Fleisch auszudrücken, geschickter als das Wachs, welches ihnen hierzu gar zu klebricht und zähe schien.

Man will unterdessen nicht behaupten, daß die Art in nassen Ton zu bilden den Griechen unbekannt, oder nicht üblich bei ihnen gewesen. Man weiß sogar den Namen desjenigen, welcher den ersten Versuch hierin gemacht hat. Dibutades von Sikyon ist der erste Meister einer Figur in Ton, und Arkesilaos, der Freund des großen Lucullus, ist mehr durch seine Modelle in Ton, als durch seine Werke selbst, berühmt worden. Er machte für den Lucullus eine Figur in Ton, welche die Glückseligkeit vorstellete, die

his composition and is more appropriate to masculine strength than to feminine modesty.

Time has, to be sure, robbed this painting of much of its glory, and its color has partially faded, but the soul which the artist breathed into the work of his hands still makes it live.

All those who approach this and other works of Raphael in the hope of finding there the trifling beauties that make the works of Dutch painters so popular: the painstaking diligence of a Netscher or a Dou, the ivory flesh tones of a Van der Werff, or the tidy manner of some of Raphael's countrymen in our times—those, I say, will never find in Raphael the great Raphael.

V. Working Methods

After the study of natural beauty, of contour, drapery, and the noble simplicity and quiet grandeur of the Greek masters, an inquiry into their working methods is necessary so that the artist may imitate them with greater success.

It is known that the Greeks often made their first models from wax. More modern masters, however, have chosen clay or similar pliable material in its stead; they found this more convenient than wax, which seemed much too sticky and hard to work, especially for the representation of flesh.

We cannot say, however, that modelling with damp clay was uncommon among the Greeks or unknown to them. We even know the name of the man who first experimented with it. Dibutades of Sicyon was the first master to create a figure in clay, and Arkesilaus, a friend of the great Lucullus, was more famous for his clay models than for his works themselves. He made for Lucullus a figure in clay representing "Felicity", which had been com-

dieser mit 60,000 Sesterzen behandelt hatte, und der Ritter Octavius gab ebendiesem Künstler ein Talent für ein bloßes Modell in Gips zu einer großen Tasse, die jener wollte in Gold arbeiten lassen.

Der Ton wäre die geschickteste Materie, Figuren zu bilden, wenn er seine Feuchtigkeit behielte. Da ihm aber diese entgehet, wenn er trocken und gebrannt wird, so werden folglich die festeren Teile desselben näher zusammentreten, und die Figur wird an ihrer Masse verlieren, und einen engeren Raum einnehmen. Litte die Figur diese Verminderung in gleichem Grade in allen ihren Punkten und Teilen, so bliebe ebendieselbe, obgleich verminderte, Verhältnis. Die kleinen Teile derselben aber werden geschwinder trocknen, als die größeren, und der Leib der Figur, als der stärkste Teil, am spätesten; und jenen wird also in gleicher Zeit mehr an ihrer Masse fehlen als diesem.

Das Wachs hat diese Unbequemlichkeit nicht: es verschwindet nichts davon, und es kann demselben die Glätte des Fleisches, die es im Poussieren nicht ohne große Mühe annehmen will, durch einen andern Weg gegeben werden.

Man machet sein Modell von Ton: man formet es in Gips, und gießet es alsdenn in Wachs.

Die eigentliche Art der Griechen aber nach ihren Modellen in Marmor zu arbeiten, scheinet nicht diejenige gewesen zu sein, welche unter den meisten heutigen Künstlern üblich ist. In dem Marmor der Alten entdecket sich allenthalben die Gewißheit und Zuversicht des Meisters, und man wird auch in ihren Werken von niedrigem Range nicht leicht dartun können, daß irgendwo etwas zu viel weggehauen worden. Diese sichere und richtige Hand der Griechen muß durch bestimmtere und zuverlässigere Regeln, als die bei uns gebräuchlich sind, notwendig sein geführet worden.

Der gewöhnliche Weg unserer Bildhauer ist, über ihre Modelle, nachdem sie dieselben wohl ausstudieret, und aufs beste geformet haben, Horizontal- und Perpendikularlinien zu ziehen, die folglich einander durchschneiden. Alsdenn verfahren sie, wie man ein Gemälde durch ein Gitter verjünget und vergrößert, und ebensoviel einander durchschneidende Linien werden auf den Stein getragen.

missioned for 60,000 sesterces, and the Roman knight Octavius paid this same artist one talent merely for a plaster model of a large cup which he wanted to have finished in gold.

Clay would be the most appropriate material for molding figures if it retained its moisture. But since the moisture is lost when it dries and is fired, the denser parts will contract more, and the figure will shrink and change its dimensions. If the figure suffered this shrinkage to an equal degree in all its parts, it would maintain the same, even though diminished, proportions. The smaller parts, however, dry faster than the larger, and the trunk of the figure, which is the thickest part, will dry last. Consequently, the smaller parts will lose proportion faster than the trunk.

Wax does not have this disadvantage; it suffers no loss of mass, and it can be given the smoothness of flesh by a method that avoids the difficult process of molding. One first makes a clay model and, from that, a plaster mold into which wax is poured.

But the actual method used by the Greeks to sculpt marble figures from their models does not seem to be that which is customary among most present-day artists. The ancient works in marble never fail to show the assurance and confidence of the master artist; even in the works of lesser merit, it is not easy to claim that too much was hewn away in any part. This sure and correct touch of the Greek artists must of necessity have been guided by more definite and dependable rules than ours.

The usual method among our sculptors is to draw horizontal and perpendicular intersecting lines on their models after they have been carefully studied and given the best form possible. Then they proceed as one does in making a larger or smaller copy of a painting with the aid of a grid, and they draw a like number of intersecting lines on the stone.

Es zeiget also ein jedes kleines Viereck des Modells seine Flächenmaße auf jedes große Viereck des Steins an. Allein weil dadurch nicht der körperliche Inhalt bestimmet werden kann, folglich auch weder der rechte Grad der Erhöhung und Vertiefung des Modells hier gar genau zu beschreiben ist: so wird der Künstler zwar seiner künftigen Figur ein gewisses Verhältnis des Modells geben können: aber da er sich nur der Kenntnis seines Auges überlassen muß, so wird er beständig zweifelhaft bleiben, ob er zu tief oder zu flach nach seinem Entwurf gearbeitet, ob er zu viel oder zu wenig Masse weggenommen.

Er kann auch weder den äußeren Umriß noch denjenigen, welcher die inneren Teile des Modells, oder diejenigen, welche gegen das Mittel zu gehen, oft nur wie mit einem Hauch anzeiget, durch solche Linien bestimmen, durch die er ganz untrüglich und ohne die geringste Abweichung ebendieselben Umrisse auf seinen Stein entwerfen könnte.

Hierzu kommt, daß in einer weitläuftigen Arbeit, welche der Bildhauer allein nicht bestreiten kann, er sich der Hand seiner Gehülfen bedienen muß, die nicht allezeit geschickt sind, die Absichten von jenem zu erreichen: Geschiehet es, daß einmal etwas verhauen ist, weil unmöglich nach dieser Art Grenzen der Tiefen können gesetzet werden, so ist der Fehler unersetzlich.

Überhaupt ist hier zu merken, daß derjenige Bildhauer, der schon bei der ersten Bearbeitung seines Steins seine Tiefen bohret, so weit als sie reichen sollen, und dieselben nicht nach und nach suchet, so, daß sie durch die letzte Hand allererst ihre gesetzte Höhlung erhalten, daß dieser, sage ich, niemals wird sein Werk von Fehlern reinigen können.

Es findet sich auch hier dieser Hauptmangel, daß die auf den Stein getragene Linien alle Augenblicke weggehauen, und ebensooft, nicht ohne Besorgnis der Abweichung, von neuen müssen gezogen und ergänzt werden.

Die Ungewißheit nach dieser Art nötigte also die Künstler, einen sichereren Weg zu suchen, und derjenige, welchen die französische Akademie in Rom erfunden, und zum Kopieren der alten Statuen zuerst gebraucht hat,

Thus each small rectangle on the model corresponds to a particular, larger rectangle on the stone. But because no determination of volume is made, this method cannot describe very exactly either the correct degree of elevation or depth of the model. It permits the artist, of course, to give his projected figure the approximate proportions of the model, but since he must rely solely on visual judgment, he will constantly remain in doubt as to whether he has cut too deeply or not deeply enough in following his model. Nor does he have lines to help him transfer to the stone, reliably and without deviation, either the outermost contours or those toward the center of the model, which are often shown ever so subtly.

There is the additional fact that for a larger work, which the sculptor cannot complete by himself, he must use assistants who are not always so skillful in carrying out his intentions. If there should be a mistake in cutting, since this method does not indicate degrees of depth, the error cannot be corrected.

In general, it can be said that the sculptor who immediately hews away the greatest depths in his stone instead of seeking them out step by step in order to give them the proper concavity only in the final stage—this sculptor, I say, will never rid his work of faults. Another important deficiency is that the lines drawn on the stone are constantly being chiselled away and thus must be redrawn and connected, not without danger of error.

Because of the uncertainty of this approach, the artists sought a more dependable way; the one discovered by the French Academy in Rome and first used for copying an-

wurde von vielen, auch im Arbeiten nach Modellen, angenommen.

Man befestiget nämlich über einer Statue, die man kopieren will, nach dem Verhältnis derselben, ein Viereck, von welchem man nach gleich eingeteilten Graden Bleifaden herunterfallen lässet. Durch diese Faden werden die äußersten Punkte der Figur deutlicher bezeichnet, als in der ersten Art durch Linien auf der Fläche, wo ein jeder Punkt der äußerste ist, geschehen konnte: sie geben auch dem Künstler ein sinnlicheres Maß von einigen der stärksten Erhöhungen und Vertiefungen durch die Grade ihrer Entfernung von Teilen, welche sie decken, und er kann durch Hülfe derselben etwas herzhafter gehen.

Da aber der Schwung einer krummen Linie durch eine einzige gerade Linie nicht genau zu bestimmen ist, so werden ebenfalls die Umrisse der Figur durch diesen Weg sehr zweifelhaft für den Künstler angedeutet, und in geringen Abweichungen von ihrer Hauptfläche wird sich derselbe alle Augenblicke ohne Leitfaden und ohne Hülfe sehen.

Es ist sehr begreiflich, daß in dieser Manier auch das wahre Verhältnis der Figuren schwer zu finden ist: Man suchet dieselben durch Horizontallinien, welche die Bleifaden durchschneiden. Die Lichtstrahlen aber aus den Vierecken, die diese von der Figur abstehende Linien machen, werden unter einem desto größeren Winkel ins Auge fallen, folglich größer erscheinen, je höher oder tiefer sie unserem Sehepunkte sind.

Zum Kopieren der Antiken, mit denen man nicht nach Gefallen umgehen kann, behalten die Bleifaden noch bis itzo ihren Wert, und man hat diese Arbeit noch nicht leichter und sicherer machen können: aber im Arbeiten nach einem Modelle ist dieser Weg aus angezeigten Gründen nicht bestimmt genug.

Michelangelo hat einen vor ihm unbekannten Weg genommen, und man muß sich wundern, da ihn die Bildhauer als ihren großen Meister verehren, daß vielleicht niemand unter ihnen sein Nachfolger geworden.

Dieser Phidias neuerer Zeiten und der Größte nach den Griechen ist, wie man vermuten könnte, auf die wahre Spur seiner großen Lehrer gekommen, wenigstens ist kein anderes Mittel der Welt bekanntgeworden, alle möglich

tique statues was accepted by many, even for working models.

Following this method the artist attaches, above the statue that he wishes to copy, a rectangular frame of corresponding dimensions from which he suspends plumb lines at equal intervals. These lines indicate the outlines of the figure more clearly than was possible with the former method of drawing lines on a surface where every point is outermost. The plumb lines also give the artist a more exact measurement of some of the larger prominences and depressions as indicated by the distance of the plumb lines from the surface, and the artist can thus proceed somewhat more confidently.

Since, however, the curvature of a line cannot be shown exactly by means of a single straight line, this method also does not give the artist a clear indication of the shape of his figure, and whenever there are slight deviations from its main outlines, he finds himself without a guide or aid.

It is also very understandable that with this method the true proportions of the figures are hard to ascertain. The artists can attempt to show them by means of horizontals placed across the plumb lines. But the light reflected from the figures through these squares strikes the eye at an angle that increases when the squares are seen from a higher or lower point of view, and thus makes them appear larger.

For the copying of antiquities, which one must treat with great care, the plumb lines still have their value since no easier or more reliable way has been discovered. But in working from a model this method is, for the above-mentioned reasons, not precise enough.

Michelangelo found a way unknown before him, and it is surprising that apparently none of the sculptors who honor him as their great master has followed his example.

This Phidias of modern times and, one might well claim, the greatest master since the Greeks, rediscovered the secret of his eminent teachers—or at least one can say, that no other method, anywhere in the world, has been

sinnlichen Teile und Schönheiten des Modells auf der Figur selbst hinüberzutragen und auszudrücken.

Vasari hat diese Erfindung desselben etwas unvollkommen beschrieben: der Begriff nach dessen Bericht ist folgender:

Michelangelo nahm ein Gefäß mit Wasser, in welches er sein Modell von Wachs oder von einer harten Materie legte: Er erhöhete dasselbe allmählich bis zur Oberfläche des Wassers. Also entdeckten sich zuerst die erhabenen Teile, und die vertieften waren bedeckt, bis endlich das ganze Modell bloß und außer dem Wasser lag. Auf ebendie Art, sagt Vasari, arbeitete Michelangelo seinen Marmor: er deutete zuerst die erhabenen Teile an, und nach und nach die tieferen.

Es scheinet, Vasari habe entweder von der Manier seines Freundes nicht den deutlichsten Begriff gehabt, oder die Nachlässigkeit in seiner Erzählung verursachet, daß man sich dieselbe etwas verschieden, von dem, was er berichtet, vorstellen muß.

Die Form des Wassergefäßes ist hier nicht deutlich genug bestimmet. Die nach und nach geschehene Erhebung seines Modells außer dem Wasser von unten auf, würde sehr mühsam sein, und setzet viel mehr voraus, als uns der Geschichtschreiber der Künstler hat wollen wissen lassen.

Man kann überzeugt sein, daß Michelangelo diesen von ihm erfundenen Weg werde aufs möglichste ausstudieret, und sich bequem gemacht haben. Er ist aller Wahrscheinlichkeit nach folgendergestalt verfahren:

Der Künstler nahm ein Gefäß nach der Form der Masse zu seiner Figur, die wir ein langes Viereck setzen wollen. Er bezeichnete die Oberfläche der Seiten dieses viereckigten Kastens mit gewissen Abteilungen, die er nach einem vergrößerten Maßstabe auf seinen Stein hinübertrug, und außerdem bemerkete er die inwendigen Seiten desselben von oben bis auf den Grund mit gewissen Graden. In dem Kasten legte er sein Modell von schwerer Materie, oder befestigte es an dem Boden, wenn es von Wachs war. Er bespannete etwa den Kasten mit einem Gitter nach den gemachten Abteilungen, nach welchen er Linien auf seinen Stein zeichnete, und vermutlich unmittelbar hernach seine Figur. Auf das Modell goß er Wasser, bis es an die äußersten Punkte der erhabenen Teile reichete, und

discovered of transferring to the figure and expressing in it all perceptible traits and beauties of the model.

Vasari has given a rather imperfect description of Michelangelo's invention. His report can be summarized as follows:[54] Michelangelo took his model of wax or some other hard material and put it in a vessel filled with water. He raised it by stages to the surface of the water in such a way that the elevated portions were uncovered first, while the depressions were still under water, until finally the entire model was exposed. According to Vasari, Michelangelo worked his marble in the same fashion, proceeding gradually from the more prominent parts to those less elevated.

It appears either that Vasari did not have a very clear conception of his friend's method, or that his careless account forces his reader to envision it as being somewhat different from his description. The form of the water container is not determined clearly enough. The gradual lifting of the model out of the water from below would be very troublesome and takes more for granted than this art historian was willing to tell us.

We can be sure that Michelangelo thought out his new method very thoroughly and made it one that was convenient to use. In all probability he proceeded as follows: He took a container appropriate to the size and shape of his model, which we shall assume to be rectangular. He marked the surface of his four-cornered container with lines at certain intervals and then transferred these to his stone according to a magnified scale, and in addition he drew gradations on the inner sides of the container from top to bottom. Then, if his model was of heavier material, he laid it on the bottom, or, if it was of wax, he fastened it there. He placed over the container a grid corresponding to the line on the edges, and drew similar lines on his stone and, presumably immediately thereafter, on his model. He then poured water on the model until it reached the outer-

nachdem er denjenigen Teil bemerket hatte, der auf seiner gezeichneten Figur erhoben werden mußte, ließ er ein gewisses Maß Wasser ab, um den erhobenen Teil des Modells etwas weiter hervorgehen zu lassen, und fing alsdenn an diesen Teil zu bearbeiten, nach dem Maße der Grade, wie er sich entdeckte. War zu gleicher Zeit ein anderer Teil seines Modells sichtbar geworden, so wurde er auch, so weit er bloß war, bearbeitet, und so verfuhr er mit allen erhabenen Teilen.

Es wurde mehr Wasser abgelassen, bis auch die Vertiefungen hervorlagen. Die Grade des Kastens zeigten ihm allemal die Höhe des gefallenen Wassers, und die Fläche des Wassers die äußerste Grundlinie der Tiefen an. Ebensoviel Grade auf seinem Steine waren seine wahren Maße.

Das Wasser beschrieb ihm nicht allein die Höhen und Tiefen, sondern auch den Kontur seines Modells; und der Raum von den inneren Seiten des Kastens bis an den Umriß der Linie des Wassers, dessen Größe die Grade der anderen zwei Seiten gaben, war in jedem Punkte das Maß, wieviel er von seinem Steine wegnehmen konnte.

Sein Werk hatte nunmehr die erste aber eine richtige Form erhalten. Die Fläche des Wassers hatte ihm eine Linie beschrieben, von welcher die äußersten Punkte der Erhobenheiten Teile sind. Diese Linie war mit dem Falle des Wassers in seinem Gefäße gleichfalls waagerecht fortgerücket, und der Künstler war dieser Bewegung mit seinem Eisen gefolget, bis dahin, wo ihm das Wasser den niedrigsten Abhang der erhabenen Teile, der mit den Flächen zusammenfließt, bloß zeigete. Er war also mit jedem verjüngten Grade in dem Kasten seines Modells einen gleichgesetzten größeren Grad auf seiner Figur fortgegangen, und auf diese Art hatte ihn die Linie des Wassers bis über den äußersten Kontur in seiner Arbeit geführet, so daß das Modell nunmehro vom Wasser entblößt lag.

Seine Figur verlangte die schöne Form. Er goß von neuem Wasser auf sein Modell, bis zu einer ihm dienlichen Höhe, und alsdenn zählete er die Grade des Kastens bis auf die Linie, welche das Wasser beschrieb, wodurch er die Höhe des erhabenen Teils ersahe. Auf ebendenselben erhabenen Teil seiner Figur legte er sein Richtscheit vollkommen waagerecht, und von der untersten Linie desselben nahm er die Maße bis auf die Vertiefung. Fand er

most points. After having noted a particular elevation on his figure, he let a certain amount of water out in order to permit this part of the model to protrude somewhat more, and then began to chisel the corresponding segment of the stone, following the measurements indicated by the exposed markings. If at the same time another part of the model became visible, it too was chiselled.

More water was let out until the depressions of the figure also appeared. The markings on the container showed him at any given moment how much the water had been lowered, and the surface of the water indicated the lowest level reached on the model. He could not go wrong since the same number of gradations were on his stone.

The water not only showed the heights and depths of his model but also its contours; and the space from the inner side of the container to the water line on the figure— as measured by the markings on the other two sides—indicated exactly how much could be safely chiselled from the stone.

His work had now received its first form, and this was a correct one. The surface of the water had given him a line on which the highest prominences of his figure were points. This horizontal line had been lowered together with the water level of the container, and the artist had followed it with his chisel down to the point where the water exposed the lowest declivities of the prominent features as they merged with the other surfaces. Proceeding thus he had transferred every small degree on the container to a corresponding larger degree on his stone figure. In this fashion the water line had guided him in the sculpting of every contour until the entire model was exposed.

His figure required beauty of form. He once more poured water on his model to an appropriate level and then measured the heights of the elevated portions by counting lines on the container from the surface of the water. On these elevated portions of his figure he placed a horizontal level and measured from its lower edge to the base of the

eine gleiche Anzahl verjüngter und größerer Grade, so war dieses eine Art geometrischer Berechnung des Inhalts, und er erhielt den Beweis, daß er richtig verfahren war.

Bei der Wiederholung seiner Arbeit suchte er den Druck und die Bewegung der Muskeln und Sehnen, den Schwung der übrigen kleinen Teile, und das Feinste der Kunst, in seinem Modelle, auch in seiner Figur auszuführen. Das Wasser, welches sich auch an die unmerklichsten Teile legte, zog den Schwung derselben aufs schärfste nach, und beschrieb ihm mit der richtigsten Linie den Kontur derselben.

Dieser Weg verhindert nicht, dem Modelle alle mögliche Lagen zu geben. Ins Profil geleget, wird es dem Künstler vollends entdecken, was er übersehen hat. Es wird ihm auch den äußeren Kontur seiner erhabenen und seiner inneren Teile und den ganzen Durchschnitt zeigen.

Alles dieses und die Hoffnung eines guten Erfolgs der Arbeit setzet ein Modell voraus, welches mit Händen der Kunst nach dem wahren Geschmack des Altertums gebildet worden.

Dieses ist die Bahn, auf welcher Michelangelo bis zur Unsterblichkeit gelanget ist. Sein Ruf und seine Belohnungen erlaubeten ihm Muße, mit solcher Sorgfalt zu arbeiten.

Ein Künstler unserer Zeiten, dem Natur und Fleiß Gaben verliehen, höher zu steigen, und welcher Wahrheit und Richtigkeit in dieser Manier findet, sieht sich genötiget, mehr nach Brot, als nach Ehre, zu arbeiten. Er bleibet also in dem ihm üblichen Gleise, worin er eine größere Fertigkeit zu zeigen glaubet, und fähret fort, sein durch langwierige Übung erlangtes Augenmaß zu seiner Regel zu nehmen.

Dieses Augenmaß, welches ihn vornehmlich führen muß, ist endlich durch praktische Wege, die zum Teil sehr zweifelhaft sind, ziemlich entscheidend worden: wie fein und zuverlässig würde er es gemacht haben, wenn er es von Jugend auf nach untrüglichen Regeln gebildet hätte?

Würden angehende Künstler bei der ersten Anführung, in Ton oder in andere Materie zu arbeiten, nach dieser sichern Manier des Michelangelo angewiesen, die dieser nach langem Forschen gefunden, so könnten sie hoffen, so nahe, wie er, den Griechen zu kommen.

prominence. If he found an equal number of gradations, this was for him a kind of geometrical calculation of the volume, and it gave him proof that he had proceeded correctly. In repeating this process he attempted to transfer to his stone figure the motions and reactions of the muscles and tendons, the undulation of the smaller parts, and the most delicate artistry of his model. The water, touching even the most unobtrusive features, traced their shape with the greatest clarity and precision.

This method permits the placement of the model in all possible positions. In the profile it reveals completely to the artist anything he has overlooked. It will show him also the contours of the elevations and depressions, and the entire diameter.

All of that, and also the hope of success in his work, presupposes a model formed by skillful hands in the true taste of antiquity.

By following this course Michelangelo attained immortality. His fame and his financial rewards gave him the leisure to work with such care. A modern artist with the talent and industry to attain greater heights does perhaps see the truth and correctness of this approach, but feels compelled to work more for bread than for honor. He therefore remains on his accustomed course, relying on an eye trained by long years of practice. This eye, which must be his main guide, has become decisive through practices that are in part very questionable. How refined and dependable it would have been if trained from childhood by infallible rules!

If young artists were taught, when they first worked with clay or other material, to follow Michelangelo's sure method, developed after much experimentation, they might hope to come as close to the Greeks as he.

VI. Malerei

Alles was zum Preis der griechischen Werke in der
Bildhauerkunst kann gesaget werden, sollte nach aller
Wahrscheinlichkeit auch von der Malerei der Griechen
gelten. Die Zeit aber und die Wut der Menschen hat uns
die Mittel geraubet, einen unumstößlichen Ausspruch
darüber zu tun.

Man gestehet den griechischen Malern Zeichnung und
Ausdruck zu; und das ist alles: Perspektiv, Komposition
und Kolorit spricht man ihnen ab. Dieses Urteil gründet
sich teils auf halb erhobene Arbeiten, teils auf die ent-
deckten Malereien der Alten (der Griechen kann man nicht
sagen) in und bei Rom, in unterirdischen Gewölbern der
Paläste des Maecenas, des Titus, Trajans und der An-
toniner, von welchen nicht viel über dreißig bis itzo ganz
erhalten worden, und einige sind nur in mosaischer Arbeit.

Turnbull hat seinem Werke von der alten Malerei eine
Sammlung der bekanntesten Stücke, von Camillo Paderni
gezeichnet, und von Mynde gestochen, beigefüget, welche
dem prächtigen und gemißbrauchten Papier seines Buchs
den einzigen Wert geben. Unter denselben sind zwei,
wovon die Originale selbst in dem Kabinett des berühmten
Arztes Richard Meads in London sind.

Daß Poussin nach der sogenannten Aldobrandinischen
Hochzeit studieret; daß sich noch Zeichnungen finden, die
Annibale Carracci nach dem vorgegebenen Marcus Cori-
olanus gemacht; und daß man eine große Gleichheit unter
den Köpfen in Guido Reni Werken, und unter den Köpfen
auf der bekannten mosaischen Entführung der Europa, hat
finden wollen, ist bereits von andern bemerket.

Wenn dergleichen Freskogemälde ein gegründetes
Urteil von der Malerei der Alten geben können; so würde
man den Künstlern unter ihnen aus Überbleibseln von
dieser Art auch die Zeichnung und den Ausdruck streitig
machen wollen.

Die von den Wänden des herkulanischen Theaters mit-
samt der Mauer versetzte Malereien mit Figuren in Lebens-
größe, geben uns, wie man versichert, einen schlechten
Begriff davon. Der Theseus, als ein Überwinder des
Minotauren, wie ihm die jungen Athenienser die Hände

56

VI. Painting

Everything that can be said in praise of Greek sculpture should in all likelihood also hold true for Greek painting. But time and human barbarity have robbed us of the means to make sure judgments.

It is conceded only that Greek painters had knowledge of contour and expression; they are given no credit for perspective, composition, or coloring. This judgment is based partly on bas-reliefs, partly on the paintings of antiquity (one cannot say that they are Greek) discovered in and near Rome, in subterranean vaults of the palaces of Maecenas, of Titus, Trajan, and the Antonini. Of these, barely thirty have been preserved intact, and some only in the form of mosaics.

Turnbull included in his work on ancient paintings[55] a collection of the best-known items, drawn by Camillo Paderni and engraved by Mynde, which give the magnificent but misused paper of his book its only value. Among them are two copies from originals in the collection of the famous physician Richard Mead of London.

Others have already noted that Poussin made studies of the so-called 'Aldobrandini Marriage',[56] that there are drawings by Annibale Carracci of a presumed 'Marcius Coriolanus', and that there is a great similarity between the heads of Guido Reni's figures and those of the well-known mosaic 'The Abduction of Europa'.

If such remnants of frescos provided the only basis for judging the ancient paintings, one might be inclined even to deny that their artists knew contour and expression. We are informed that the paintings with life-sized figures taken, together with the walls, from the theater in Herculaneum give a poor impression of their skills: Theseus as the conqueror of the Minotaur,[57] with the young Ath-

küssen und seine Knie umfassen: die Flora nebst den Herkules und einen Faun: der vorgegebene Gerichtsspruch des Dezemvirs Appius Claudius, sind nach dem Augenzeugnis eines Künstlers zum Teil mittelmäßig, und zum Teil fehlerhaft gezeichnet. In den mehresten Köpfen ist, wie man versichert, nicht allein kein Ausdruck, sondern in dem Appius Claudius sind auch keine guten Charaktere.

Aber ebendieses beweiset, daß es Malereien von der Hand sehr mittelmäßiger Meister sind; da die Wissenschaft der schönen Verhältnisse, der Umrisse der Körper, und des Ausdrucks bei griechischen Bildhauern, auch ihren guten Malern eigen gewesen sein muß.

Diese den alten Malern zugestandene Teile der Kunst lassen den neuern Malern noch sehr viel Verdienste um dieselbe.

In der Perspektiv gehöret ihnen der Vorzug unstreitig, und er bleibt, bei aller gelehrten Verteidigung der Alten, in Ansehung dieser Wissenschaft, auf seiten der Neueren. Die Gesetze der Komposition und Ordonnance waren den Alten nur zum Teil und unvollkommen bekannt; wie die erhobenen Arbeiten von Zeiten, wo die griechischen Künste in Rom geblühet, dartun können.

In der Kolorit scheinen die Nachrichten in den Schriften der Alten und die Überbleibsel der alten Malerei auch zum Vorteil der neuern Künstler zu entscheiden.

Verschiedene Arten von Vorstellungen der Malerei sind gleichfalls zu einen höheren Grad der Vollkommenheit in neuern Zeiten gelanget. In Viehstücken und Landschaften haben unsere Maler allem Ansehen nach die alten Maler übertroffen. Die schönern Arten von Tieren unter andern Himmelstrichen scheinen ihnen nicht bekannt gewesen zu sein; wenn man aus einzelnen Fällen, von dem Pferde des Marcus Aurelius, von den beiden Pferden in Monte Cavallo, ja von den vorgegebenen Lysippischen Pferden über dem Portal der St. Markuskirche in Venedig, von dem Farnesischen Ochsen und den übrigen Tieren dieses Gruppo, schließen darf.

Es ist hier im Vorbeigehen anzuführen, daß die Alten bei ihren Pfereden die diametralische Bewegung der Beine nicht beobachtet haben, wie an den Pferden in Venedig und auf alten Münzen zu sehen ist. Einige Neuere sind ihnen

enians embracing his knees and kissing his hands; Flora with Hercules and a faun; an alleged 'Judgment of the Decemvir Appius Claudius'—all are, according to the testimony of an artist, either mediocre or poor. Not only do most of the faces lack expression but those in the 'Appius Claudius' lack even character. But this very fact proves that they are paintings by very mediocre artists; for the knowledge of beautiful proportion, of bodily contour, and expression found in Greek sculptors must also have been possessed by their good painters.

Although the ancient painters deserve recognition of their accomplishments, much credit is also due the moderns. In the science of perspective modern painters are clearly superior despite all learned defense of the ancients. The laws of composition and arrangement were imperfectly known to antiquity as evidenced by bas-reliefs dating from the times when Greek art flourished in Rome. As for the use of color, both the accounts of ancient writers and the remains of ancient paintings testify in favor of the moderns.

Various other objects of painting have likewise been raised to a higher degree of perfection in more modern times, for example, landscapes and animal species. The ancient painters seem not to have been acquainted with more handsome species of animals in other regions, if one may judge from individual cases such as the horse of Marcus Aurelius, the two horses in Monte Cavallo, the horses above the portal of San Marco's Church in Venice, presumably by Lysippus, or the Farnesian Bull and the other animals of this group.

It should be mentioned in passing that in the portrayal of horses the ancients did not observe the diametrical movements of the legs as seen in the Venetian horses and those depicted on old coins. Some modern artists have, in

hierin aus Unwissenheit gefolget, und sogar verteidiget worden.

Unsere Landschaften, sonderlich der niederländischen Maler, haben ihre Schönheit vornehmlich dem Ölmalen zu danken: ihre Farben haben dadurch mehrere Kraft, Freudigkeit und Erhobenheit erlanget, und die Natur selbst unter einem dickern und feuchtern Himmel hat zur Erweiterung der Kunst in dieser Art nicht wenig beigetragen.

Es verdienten die angezeigten und einige andere Vorzüge der neuern Maler vor den alten, in ein größeres Licht, durch gründlichere Beweise, als noch bisher geschehen ist, gesetzet zu werden.

VII. Allegorie

Zur Erweiterung der Kunst ist noch ein großer Schritt übrig zu tun. Der Künstler, welcher von der gemeinen Bahn abzuweichen anfängt, oder wirklich abgewichen ist, suchet diesen Schritt zu wagen; aber sein Fuß bleibet an dem jähesten Orte der Kunst stehen, und hier siehet er sich hülflos.

Die Geschichte der Heiligen, die Fabeln und Verwandlungen sind der ewige und fast einzige Vorwurf der neuern Maler seit einigen Jahrhunderten: Man hat sie auf tausenderlei Art gewandt und ausgekünstelt, daß endlich Überdruß und Ekel den Weisen in der Kunst und den Kenner überfallen muß.

Ein Künstler, der eine Seele hat, die denken gelernet, läßt dieselbe müßig und ohne Beschäftigung bei einer Daphne und bei einem Apollo; bei einer Entführung der Proserpina, einer Europa und bei dergleichen. Er suchet sich als einen Dichter zu zeigen, und Figuren durch Bilder, das ist, allegorisch zu malen.

Die Malerei erstreckt sich auch auf Dinge, die nicht sinnlich sind; diese sind ihr höchstes Ziel, und die Griechen haben sich bemühet, dasselbe zu erreichen, wie die Schriften der Alten bezeugen. Parrhasios, ein Maler, der wie Aristides die Seele schilderte, hat sogar, wie man sagt,

their ignorance, followed their example and have even been defended for doing so.

Our landscapes, especially those of the Dutch, owe their beauty mainly to the fact that they are painted in oil; their colors are stronger, more lively and vivid. Nature itself, under a thicker and moister atmosphere, has contributed not a little to the growth of this type of art. These and other advantages of modern painters over the ancients deserve to be better demonstrated, with more thorough proof than heretofore.

VII. Allegory

There is one other important step to be taken in the further development of art. The artist who begins to stray from the common path or already has left it makes a bold attempt, but falters before this steepest precipice of art and is helpless.

The stories of the saints, the legends and metamorphoses, have for several centuries been almost the only objects of painters. They have been varied and contrived in a thousand ways until finally the connoisseur of art is bored and disgusted.

An artist of thoughtful mind finds no challenge in a Daphne and Apollo or in an abduction of Proserpina, an Europa, and so on.[58] He wants to show his poetic ability and paint figures by means of significant images, that is, paint allegorically.

For painting goes beyond the things of the senses; that is its highest goal and one the Greeks strove to attain, as their writings testify. We are told that Parrhasius, like Aristeides a painter of the soul, was able even to express

den Charakter eines ganzen Volks ausdrücken können. Er malete die Athenienser, wie sie gütig und zugleich grausam, leichtsinnig und zugleich hartnäckig, brav und zugleich feige waren. Scheinet die Vorstellung möglich, so ist sie es nur allein durch den Weg der Allegorie, durch Bilder, die allgemeine Begriffe bedeuten.

Der Künstler befindet sich hier wie in einer Einöde. Die Sprachen der wilden Indianer, die einen großen Mangel an dergleichen Begriffen haben, und die kein Wort enthalten, welches Erkenntlichkeit, Raum, Dauer usw. bezeichnen könnte, sind nicht leerer von solchen Zeichen, als es die Malerei zu unseren Zeiten ist. Derjenige Maler, der weiter denket als seine Palette reichet, wünschet einen gelehrten Vorrat zu haben, wohin er gehen, und bedeutende und sinnlich gemachte Zeichen von Dingen, die nicht sinnlich sind, nehmen könnte. Ein vollständig Werk in dieser Art ist noch nicht vorhanden: die bisherigen Versuche sind nicht beträchtlich genug, und reichen nicht bis an diese große Absichten. Der Künstler wird wissen, wie weit ihm des Ripa Ikonologie, die Denkbilder der alten Völker von de Hooghe Gnüge tun werden.

Dieses ist die Ursach, daß die größten Maler nur bekannte Vorwürfe gewählet. Annibale Carracci, anstatt, daß er die berühmtesten Taten und Begebenheiten des Hauses Farnese in der Farnesischen Galerie, als ein allegorischer Dichter durch allgemeine Symbola und durch sinnliche Bilder hätte vorstellen können, hat hier seine ganze Stärke bloß in bekannten Fabeln gezeiget.

Die königliche Galerie der Schildereien in Dresden enthält ohne Zweifel einen Schatz von Werken der größten Meister, der vielleicht alle Galerien in der Welt übertrifft, und Seine Majestät haben, als der weiseste Kenner der schönen Künste, nach einer strengen Wahl nur das Vollkommenste in seiner Art gesuchet; aber wie wenig historische Werke findet man in diesem königlichen Schatze! von allegorischen, von dichterischen Gemälden noch weniger.

Der große Rubens ist der vorzüglichste unter großen Malern, der sich auf den unbetretenen Weg dieser Malerei in großen Werken als ein erhabener Dichter, gewaget. Die Luxemburgische Galerie, als sein größtes Werk, ist durch

the character of an entire people. He painted the Athenians as kindly but also cruel, capricious but steadfast, brave but cowardly. Such representations could only be accomplished by the use of allegory, by images signifying general ideas.

Here the artist finds himself in a wasteland. The languages of the wild Indians, which have a great dearth of such ideas and possess no word for 'acknowledgement', 'space', 'duration', etc., are no more devoid of such signs than is the painting of today. Any painter who thinks beyond his palette wants to have readily available a learned store of meaningful and clear images for abstract ideas. There is as yet no complete compendium of this type. Previous attempts have not been substantial enough and do not attain these high purposes. An artist knows how little satisfaction is to be found in Ripa's *Iconology* or in de Hooghe's *Hieroglyphica*.[59]

This is the reason why the greatest painters chose only widely known subjects. Annibale Carracci, instead of portraying the most famous deeds and events of the Farnese family in the Farnesian Gallery, as he might have done in the manner of an allegorical poet using general symbols and images, reserved his entire talent for familiar stories. The gallery in Dresden contains without a doubt a treasure of masterworks surpassing perhaps all other galleries in the world, and His Majesty, the wisest connoisseur of the fine arts, has most carefully selected only the most perfect of its kind. Yet, how few historical works can be found in this royal treasure—and even fewer allegorical, poetic paintings!

Among great artists, Rubens is the most eminent of those who have dared to walk the untrodden path of poetic painting in their major works. His cycle of paintings in the Luxemburg Gallery,[60] as his greatest undertaking, is

die Hand der geschicktesten Kupferstecher der ganzen Welt bekannt worden.

Nach ihm ist in neueren Zeiten nicht leicht ein erhabeners Werk in dieser Art unternommen und ausgeführet worden, dergleichen die Cuppola der Kaiserlichen Bibliothek in Wien ist, von Daniel Gran gemalet, und von Sedelmayr in Kupfer gestochen. Die Vergötterung des Herkules in Versailles, als eine Allusion auf den Kardinal Hercule de Fleury, von Lemoyne gemalet, womit Frankreich als mit der größten Komposition in der Welt pranget, ist gegen die gelehrte und sinnreiche Malerei des deutschen Künstlers eine sehr gemeine und kurzsichtige Allegorie: sie ist wie ein Lobgedicht, worin die stärksten Gedanken sich auf den Namen im Kalender beziehen. Hier war der Ort, etwas Großes zu machen, und man muß sich wundern, daß es nicht geschehen ist. Man siehet aber auch zugleich ein, hätte auch die Vergötterung eines Ministers den vornehmsten Plafond des königlichen Schlosses zieren sollen, woran es dem Maler gefehlet.

Der Künstler hat ein Werk vonnöten, welches aus der ganzen Mythologie, aus den besten Dichtern alter und neuerer Zeiten, aus der geheimen Weltweisheit vieler Völker, aus den Denkmalen des Altertums auf Steinen, Münzen und Geräten diejenige sinnliche Figuren und Bilder enthält, wodurch allgemeine Begriffe dichterisch gebildet worden. Dieser reiche Stoff würde in gewisse bequeme Klassen zu bringen, und durch eine besondere Anwendung und Deutung auf mögliche einzelne Fälle, zum Unterricht der Künstler, einzurichten sein.

Hierdurch würde zu gleicher Zeit ein großes Feld geöffnet, zur Nachahmung der Alten, und unsern Werken einen erhabenen Geschmack des Altertums zu geben.

Der gute Geschmack in unsern heutigen Verzierungen, welcher seit der Zeit, da Vitruv bittere Klagen über das Verderbnis desselben führete, sich in neueren Zeiten noch mehr verderbet hat, teils durch die von Morto, einem Maler von Feltre gebürtig, in Schwang gebrachte Grotesken, teils durch nichts bedeutende Malereien unserer Zimmer, könnte zugleich durch ein gründlicheres Studium der Allegorie gereiniget werden, und Wahrheit und Verstand erhalten.

known throughout the world from copies made by the best engravers.

Since Rubens' time only a few distinguished works of this type have been undertaken and completed, among them the cupola of the Imperial Library in Vienna, painted by Daniel Gran[61] and engraved in copper by Sedelmayr. The 'Apotheosis of Hercules' in Versailles, painted by Le Moyne as an allusion to the Cardinal Hercule de Fleury —which France boasted of as the greatest composition in the world—is, compared with the learned and ingenious painting of the German artist, a very ordinary and short-sighted allegory; it resembles a panegyric whose most striking ideas relate to a name in the calendar. This was an opportunity for the artist to achieve grandeur, and one can only be surprised that he failed. Even though he was given the most important ceiling of the royal palace for the apotheosis of a minister of state, it is easy to see what he was lacking.

The artist needs a work containing those meaningful figures and images that give poetic form to general ideas, a work drawn from all mythology, from ancient and modern writers, from the mysterious wisdom of many nations, from the monuments of antiquity preserved on gems, coins, and utensils. This wealth of material should be conveniently classified and, with proper application to particular cases, be adapted to the instruction of the artist.[62] It would at the same time open to us a vast area for imitation of the ancients and the imparting of their sublime taste to our works.

In modern decorative work, good taste has declined even more than when Vitruvius bitterly complained of its corruption in the Rome of his days. This is due partly to the grotesques made popular by Morto da Feltre, and also to the frivolous paintings of buildings and rooms. A more thorough study of allegory could purify this taste and provide it with reality and common sense.

Unsere Schnirkel und das allerliebste Muschelwerk, ohne welches itzo keine Zierat förmlich werden kann, hat manchmal nicht mehr Natur als Vitruvs Leuchter, welche kleine Schlösser und Paläste trugen. Die Allegorie könnte eine Gelehrsamkeit an die Hand geben, auch die kleinsten Verzierungen dem Orte, wo sie stehen, gemäß zu machen.

Reddere personae scit convenientia cuique.

HOR.

Die Gemälde an Decken und über den Türen stehen mehrenteils nur da, um ihren Ort zu füllen, und um die ledigen Plätze zu decken, welche nicht mit lauter Vergöldungen können angefüllet werden. Sie haben nicht allein kein Verhältnis mit dem Stande und mit den Umständen des Besitzers, sondern sie sind demselben sogar oftmals nachteilig.

Der Abscheu vor den leeren Raum füllet also die Wände; und Gemälde von Gedanken leer, sollen das Leere ersetzen.

Dieses ist die Ursach, daß der Künstler, dem man seiner Willkür überläßt, aus Mangel allegorischer Bilder oft Vorwürfe wählet, die mehr zur Satire, als zur Ehre desjenigen, dem er seine Kunst weihet, gereichen müssen: und vielleicht, um sich hiervor in Sicherheit zu stellen, verlanget man aus feiner Vorsicht von dem Maler, Bilder zu machen, die nichts bedeuten sollen.

Es macht oft Mühe, auch dergleichen zu finden, und endlich

velut aegri somnia, vanae
Fingentur species. HOR.

Man benimmt also der Malerei dasjenige, worin ihr größtes Glück bestehet, nämlich die Vorstellung unsichtbarer, vergangener und zukünftiger Dinge.

Diejenigen Malereien aber, welche an diesem oder jenem Orte bedeutend werden könnten, verlieren das, was sie tun würden, durch einen gleichgültigen oder unbequemen Platz, den man ihnen anweiset.

Der Bauherr eines neuen Gebäudes

Dives agris, dives positis in foenere nummis.

HOR.

The extravagant scrolls and precious shell-work, without which no decoration is considered proper these days,[63] are often as far removed from nature as Vitruvius's lamps, from which hung little castles and palaces. Allegory could provide the knowledge that would make even the smallest ornamentations appropriate to their location.

Reddere personae scit convenientia cuique.

HORACE[64]

The paintings on ceilings and over doors are usually there only to fill space, to cover surfaces which cannot be filled by gilding alone. They not only have no relation to the station and circumstances of their owner, but frequently even do detriment to him. Thus an abhorrence of empty spaces causes the walls to be filled with paintings devoid of content.

Hence the artist, left to his own fancy and lacking allegorical motifs, often chooses subjects that do more to satirize than to honor the one for whom he is painting. And a cautious patron will perhaps, in order to prevent this, request figures without meaning. But even these are often difficult to find, and, in the end,

Velut aegri somnia, vanae
Fingentur species.

HORACE[65]

Thus painting is deprived of that which is its greatest fortune—the representation of invisible, past, and future things.

Those paintings, however, which could be significant in some particular spot will, if wrongly placed, lose any effect they might have had. The owner of a new building,

Dives agris, dives positis in foenere nummis.

HORACE[66]

wird vielleicht über die hohen Türen seiner Zimmer und Säle kleine Bilder setzen lassen, die wider den Augenpunkt und wider die Gründe der Perspektiv anstoßen. Die Rede ist hier von solchen Stücken, die ein Teil der festen und unbeweglichen Zieraten sind; nicht von solchen, die in einer Sammlung nach der Symmetrie geordnet werden.

Die Wahl in Verzierungen der Baukunst ist zuweilen nicht gründlicher: Armaturen und Trophäen werden allemal auf ein Jagdhaus ebenso unbequem stehen, als Ganymedes und der Adler, Jupiter und Leda unter der erhobenen Arbeit der Türen von Erzt, am Eingang der St. Peterskirche in Rom.

Alle Künste haben einen gedoppelten Endzweck: sie sollen vergnügen und zugleich unterrichten, und viele von den größten Landschaftmalern haben daher geglaubet, sie würden ihrer Kunst nur zur Hälfte ein Genüge getan haben, wenn sie ihre Landschaften ohne alle Figuren gelassen hätten.

Der Pinsel, den der Künstler führet, soll im Verstand getunkt sein, wie jemand von dem Schreibegriffel des Aristoteles gesaget hat: Er soll mehr zu denken hinterlassen, als was er dem Auge gezeiget, und dieses wird der Künstler erhalten, wenn er seine Gedanken in Allegorien nicht zu verstecken, sondern einzukleiden gelernet hat. Hat er einen Vorwurf, den er selbst gewählet, oder der ihm gegeben worden, welcher dichterisch gemacht, oder zu machen ist, so wird ihn seine Kunst begeistern, und wird das Feuer, welches Prometheus den Göttern raubete, in ihm erwecken. Der Kenner wird zu denken haben, und der bloße Liebhaber wird es lernen.

will perhaps place small pictures over the high doors of his parlors and chambers in defiance of every rule of perspective. We are speaking here of those pieces which form a part of the permanent decoration, not of these which are in a particular arrangement as part of a collection.

The selection of ornamental motifs in architecture is at times just as careless. Weaponry and trophies in the decoration of a hunting lodge are, without fail, as inappropriately placed as are 'Ganymede and the Eagle' or 'Jupiter and Leda' under the reliefs on the bronze entrance doors of St. Peter's in Rome.[67]

All arts have a double aim: to delight and instruct. Hence many of the greatest landscape painters have believed that they would do only partial justice to their art if they did not include human figures in their landscapes.

Let the artist's brush, like Aristotle's pen, be imbued with reason. He should leave our minds with more than he has shown our eyes, and he will attain this goal if he has learned to use allegory not to conceal his ideas but to clothe them. Then, whether he has a poetical object of his own choice or someone else's, his art will inspire him and kindle in him the flame which Prometheus took from the gods. The connoisseur will have food for thought and the mere admirer of art will learn to think.

Notes on Introduction

1. Leipzig, Vol. I, 1866, and Vols. II & III, 1872.

2. For a detailed investigation of Winckelmann criticism up to the late 1950s, see Ingrid Kreuzer, *Studien zu Winckelmanns Aesthetik* (Berlin, 1959). Kreuzer surveys the reception of Winckelmann by various disciplines (art history, history, literary criticism) and tries to demonstrate with selected examples how inherent contradictions in Winckelmann's works have slowly been transmitted into the research on him—a fact, Kreuzer claims, which has contributed to a dreadful contorting of his image.

3. Johann Gottfried Herder, 'Denkmahl Johann Winckelmanns 1778' in *Herders Werke*, ed. Bernhard Suphan (Berlin: Weidmannsche Buchhandlung, 1892), VIII.

4. Wolfgang Leppmann, *Winckelmann* (New York: Alfred A. Knopf, 1970), p. 55. Some general biographical information regarding Winckelmann given in this introduction is also from Leppmann.

5. Our translation from the German 'Beschreibung des Torso im Belvedere zu Rom' in *Winckelmanns Werke*, ed. Holtzhauer, p. 56; first published in *Bibliothek der schönen Wissenschaften und der freien Künste* (Berlin, 1759).

6. Quoted by David Irwin, editor of *Winckelmann: Writings on Art* (London: Phaidon Press, 1972), p. 9.

7. There has been considerable speculation about the role that homosexuality may have played as a possible motive for his murder. We believe that Leppmann's well-researched account (op.cit.) should do much to clarify this matter.

Notes on REFLECTIONS

Winckelmann's own notes have been included, exactly as they appear in the original German edition; they are placed within parentheses and are preceded, for purposes of identification, by "*W*":

1. (*W*: Plato in Timaeo, edit. Francof. p. 1004.) Plato wrote in *Timaios* that the goddess Athena (Minerva) founded the Athenian state in the Grecian landscape because "the happy combination of seasons there was best suited for the breeding of wise people."

2. A reference to paintings from the collection of Rudolph II, which were taken from Prague to Dresden by the conquering Swedes in 1648.

3. "The great August" is the Electoral Prince August I of Saxony, who also ruled Poland under the title of August II (August the Strong).

His son and successor was Friedrich August, to whom Winckelmann dedicates this work. Winckelmann flatters him here by comparing him with the Roman emperor Titus Flavius Vespasianus, who was known as a particularly beneficent ruler.

4. A famous marble group representing Laocoon and his two sons in the coils of two snakes (see note 38).

5. Dido was the legendary founder of Carthage and a figure in Virgil's *Aeneid* and Homer's *Odyssey*.

6. Polyclitus was a Greek sculptor of the 5th century B.C., who was the first to develop universally valid laws of proportion, with the help of which he wanted to create the ideal form of the human body.

7. The Medicean Venus was a copy of an Aphrodite (Venus) statue, made during the time of the Roman Imperium, later in possession of the Medici family.

8. A mythical hero of the Trojan War.

9. (W: Proclus in Timaeum Platonis.)

10. Hercules was the son of Zeus and Alcmene, Iphicles, the son of Amphitryon and Alcmene. According to Hesiod's account they were borne as twins.

11. A person dedicated to luxurious living, an epicure. The name is derived from the inhabitants of Sybaris in southern Italy.

12. An area on the west coast of the Peloponnesian peninsula. The most famous games of antiquity took place there in the valley of Olympia.

13. Diagoras was the hero of an ode by Pindar. (W: v. Pindar. Olymp. Od. VII. Arg. & Schol.)

14. The Ephors were the highest officials of the Spartan state.

15. Claude Quillet's Latin didactic poem *Callipaedia* (1645) deals with methods for conceiving beautiful children.

16. The Kabardians are a Cherkessian tribe native to the Caucasus.

17. Places for physical exercise, which gradually became centers of intellectual life (Greek: *gymnazein*, "to train naked").

18. The games taking place in Eleusis in antiquity were dedicated to the worship of the fertility goddess, Demeter.

19. "Anadyomene": 'The woman arising from the sea foam'.

20. An allusion to the primitive Christians, who lived in brotherhood communities and who, from the time of the apostles until about 150 A.D., protested against exploitation and oppression and proclaimed the equality and brotherhood of all men.

21. Ionia: coastal area in the western part of Asia Minor.

22. Some commentators conjecture that this gladiator, of whom Pliny speaks, is the famous Ludovisian 'Dying Gladiator', now displayed in the large hall of the Capitoline Museum in Rome.

23. Raphael, Castiglione: (W: v. Bellori Descriz. delle Imagine depinte da Rafaelle d'Urbino etc. Roma, 1695. fol.)

24. Euodus etc.: (W: v. Stosch Pierres grav. pl. XXXIII.) W.'s note refers to Stosch, *Gemmae Antiquae*, with engravings by Picart (Amsterdam, 1724).

25. (W: v. Baldinucci Vita del Cav. Bernino.)

26. The "admirable" Antinoüs, a handsome youth from Bithynia, was the favorite of Emperor Hadrian. After his death he was raised by Hadrian to the status of a god.

27. A reference to the statue of the Apollo of Belvedere (the Belvedere Gallery of the Vatican) by Leochares in the 4th century B.C.

28. "For whom Prometheus has made hearts with greater skill and better substance," Juvenal, *Sat.* XIV, 34 f.

29. (*W:* v. Stosch Pierres grav. pl. XXIX. XXX.)

30. ("*W:* v. Mus. Flor. T. II t.V.) The beautiful princess Iole was, according to Greek legend, promised by her father Eurytos as a bride to the one who should conquer him and his son in archery. Hercules fulfilled this condition, but when Iole was not given to him he took vengeance by abducting her.

31. Kos (Cos) was known for making clothes out of a fabric so thin and veil-like that the body could be seen through it.

32. (*W:* v. Zanetti, Statue nell' Antisala della Libreria di S. Marco, Venez. 1740 fol.)

33. In 29 A.D. Agrippina was banished to the island of Pandateria, off the west coast of central Italy, by Emperor Tiberius, whom she accused of the murder of her husband, Germanicus.

34. These statues are no longer regarded as vestals but as burial monument figures of women of Herculaneum. This city, together with Pompeii, was covered by ashes from the eruption of Mt. Vesuvius in 79 A.D.

35. See n. 34.

36. Italian for 'room on the ground floor'.

37. Mattielli and Algarotti: Lorenzo Mattielli (1688-1748) was an Italian sculptor who worked first in Vienna then, after 1743, in Dresden, where he created among other works the statues for the Hofkirche. Count Francesco Algarotti (1712-1764) was a leading Italian critic in the mid-18th century. The quotation is from a poem concerning the influence of ancient Greece and Rome.

38. Laocoon: This marble group, which represents Laocoon, priest of Apollo at Troy, and his two sons in the coils of two snakes, was created apparently in the first century B.C. by Agesander, Polydorus, and Athenodorus of Rhodes. It was rediscovered in Rome in 1506 and transferred to the Vatican. Since Virgil in his Aeneid describes the death throes of Laocoon in similar fashion (Aeneid II, 213-224) it is assumed that he knew this sculpture. In Virgil, to be sure, Laocoon's "terrible screaming" during the struggle is described, and Lessing's disagreement with Winckelmann's interpretation of the statue and what it depicted provided the initial impulse for Lessing's critical work, *Laokoon oder über die Grenzen der Malerei und Poesie* (*Laocoon or the Limits of Painting and Poetry*).

39. Jacopo Sadoleto dedicated his Latin poem 'De Laocoontis statua' to this marble group, which had just been rediscovered.

40. Philoctetes, who inherited the bow and arrows of his friend Hercules, was bitten by a snake during the journey of the Greeks against Troy and had to be left on the island of Lemmos because of the unbearable odor of his wound. He lived there in needy circumstances until Ulysses and Diomedes (in Sophocles: Neoptolemus) brought him to Troy where his skill with the bow was needed and where he killed Paris with one of his poisoned arrows. Sophocles' tragedy *Philoctetes* was discussed in detail by Lessing in his *Laocoon*.

41. Metrodorus of Athens, painter and Epicurean philosopher, went to Rome in 168 B.C. in order to tutor the children of L. Aemilius Paulus and to produce paintings glorifying the military triumphs of Paulus.

42. Parenthyrsos was originally a term used in rhetoric, signifying exaggerated, out-of-place pathos.

43. An Italian term for 'openness', 'sincerity', 'frankness'.

44. Italian for 'contrast'. In sculpture it signifies an assymetrical pose involving a strong contrast between the position of the leg carrying the body weight and the other leg.

45. Ajax was the strongest and wildest Greek hero of the Trojan War, a rival of Ulysses, who in his madness killed a herd of sheep and then himself. Capaneus was a figure in the cycle of legends concerning Thebes, known for his arrogance. He was one of the 'Seven against Thebes'; as he was storming the wall during the siege of the city, he boasted that not even Zeus could keep him out, and the angry Zeus struck him down with a lightning bolt.

46. Hyperbole: Poetical or rhetorical exaggeration.

47. "So that everyone thinks he can do it too; yet, however hard he sweats and strives, his attempt is in vain" Horace, *Ars poetica*, 240–243.

48. Raphael portrays the legendary encounter between the king of the Huns and Pope Leo I, who is referred to here in his capacity as Bishop of Rome. When Attila and his army attacked Italy in the year 452, the Pope is said to have succeeded in persuading him to spare Rome.

49. "When they see then a man so worthy and venerable, they all keep silence and listen attentively" Virgil, *Aeneid* I, 151 f.

50. (*W: v. Wright's Travels.*)

51. A reference to Joseph Addison (1672–1719), whose poem 'The Campaign' (1704) eulogizes the Duke of Marlborough (1650–1722), under whose leadership an English army conquered the French in the battle of Blenheim.

52. This 'Sistine Madonna' had been brought to Dresden in 1753.

53. An ancient city in Central Greece.

54. Winckelmann includes in his notes an eleven-line quotation in Italian ascribed to "Vasari, Vite de' Pittori, Scult. & Archit. edit. 1568, Part. III, p. 776", which we shall omit here. The Reclam edition of *Gedanken . . .* comments thus on W.'s description of Vasari's report: "Winckelmann's hypothesis that Michelangelo established the contours of sculptural models with the aid of a water container, could only be based on a reference in Giorgio Vasari's *Vite de' Pittori*, in which the delineation of sculptural lines by means of a water surface appears only as a figurative comparison. The procedure which Winckelmann describes in such detail is therefore probably a pure invention of Winckelmann or of his friend Adam Friedrich Oeser, as Carl Justi has conjectured" (Carl Justi: *Winckelmann und seine Zeitgenossen*, 5. Aufl. Bd 1, Köln 1956, S. 474–481). (Reclam quotation is from Ludwig Uhlig's edition of Winckelmann's *Gedanken . . .* , Universal-Bibliothek #8338 (2), 1977, p. 131, as translated by us.)

55. (*W: Turnbull's Treatise on Ancient Painting, 1740. fol.*)

56. A fresco of the first century A.D., rediscovered in Rome in 1606.

57. The legendary Attic national hero, Theseus, killed the monster Minotaur which every year, at the behest of the Cretan king, Minos, had received seven Athenian boys and girls to devour.

58. According to Greek legend, Proserpina (Persephone), the daughter of Demeter, was abducted by Hades and taken as his bride to the underworld. Europa: The Phonician princess Europa was carried over the sea to Crete by Zeus, who had changed himself into a bull.

59. A reference to the emblem collections by Cesare Ripa, *Iconologia ovvero descrittione dell' imagini universali cavati dall' antichità* (1593) and by Romeyn de Hooghe, *Hieroglyphica of Merkbeelden der oude volkeren* (1735, published in German in 1744 under the title *Hieroglyphica oder Denkbilder der alten Völker*).

60. This was a series of paintings on the life of Maria de' Medici which Rubens produced for the Palais du Luxembourg.

61. 1694–1757, Viennese painter and teacher of Oeser.

62. With his *Versuch einer Allegorie* (1766) Winckelmann fulfilled in part the wish expressed here.

63. Winckelmann is alluding here to elements of the extremely ornate style of the Rococo period, which he despised.

64. "He knows how to give every person his most fitting role" Horace, *Ars poetica* 316.

65. "Foolish fancies will arise like the dreams of a fevered patient" Horace, *Ars poetica* 7 f.

66. "Rich in property, rich in interest-bearing capital" Horace, *Sat.* I, 2, 13 and *Ars poetica* 421.

67. Winckelmann has in mind here, firstly, the decorative sculptures which were placed on the walls of the royal hunting lodge of Hubertusburg after Oeser's plans had been rejected, and, secondly, the famous Porta Mediana of St. Peter's by Filarete, which incorporates both Christian and pagan iconography. Ganymede: Because of his beauty, the Trojan youth Ganymede was carried off by Zeus in the form of an eagle and made cup-bearer of the gods on Olympus. Jupiter and Leda: Zeus (Jupiter) in the form of a swan made love to the Aetolian princess Leda.

75